LETTERING TECHNIQUES

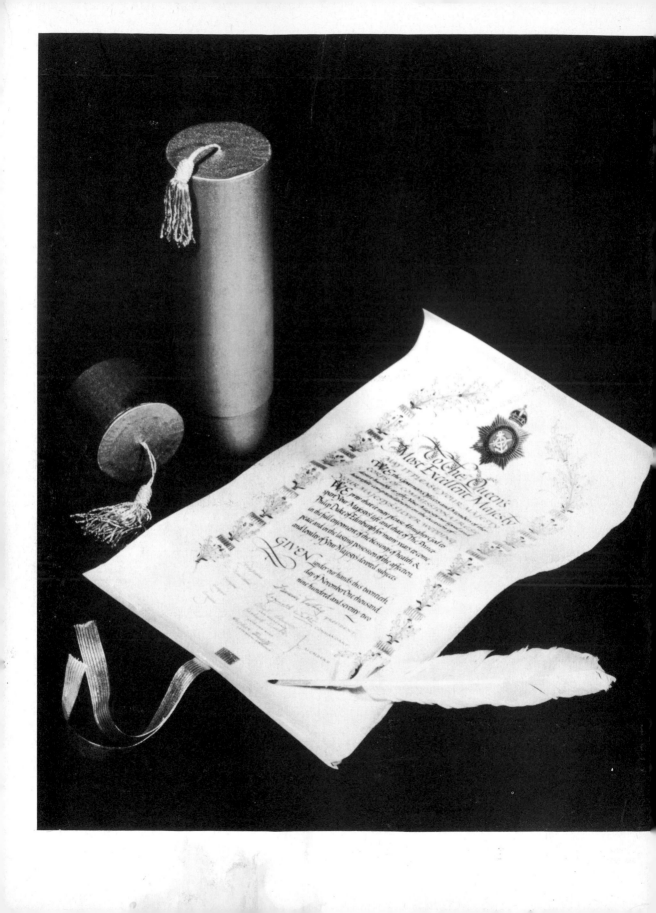

Lettering Techniques

John Lancaster

B. T. BATSFORD LTD, LONDON

This book is dedicated to Simon for twenty
years of unsparing affection and pleasure

Frontispiece and cover
illustration

This Loyal Address in black, blue,
silver, raised-gold and colour on
vellum, was presented to Her
Majesty The Queen, on the
occasion of Her Majesty's Silver
Wedding, in 1972. It was written
and illuminated by Lionel Joseph
Smith and it is a particularly beauti-
ful example of mid twentieth-
century craftsmanship. The scroll
is kept in a presentation tube which
is attractively adorned with silver
tassels
Reproduced by gracious permission
of Her Majesty The Queen

© John Lancaster 1980
First published 1980
Reprinted in paperback 1982
ISBN 0 7134 0221 0

Set in IBM Theme by
Tek-Art Ltd London SE20
Printed and bound in Great Britain
by The Anchor Press
Tiptree, Essex
for the publishers
B. T. Batsford Ltd
4 Fitzhardinge Street, London W1H 0AH

Contents

Acknowledgment

This publication was inspired by Thelma Nye, my editor, to whom I should like to express my appreciation and esteem. Her confidence in my ability to produce a suitable text has been a continual inspiration, although she has probably been surprised at the liberties which I have taken and the way the original ideas have become 'elasticated'.

Of the numerous people who have been kind enough to advise me in the writing of this book, and the individuals and institutions for their generous help in supplying me with illustrative material and permission to reproduce chosen examples, I should like to thank in particular: Her Majesty The Queen; The Lord Chamberlain; William Heseltine; Hugh Collinson; Adam Scott; Guy St John Scott; Peter Rock; Bryant Fedden; Susan Eaton; Martin Vinall; E John Milton-Smith; Thomas Barnard; Catherine Redding; David Howells; David Wade; Mike George; the Art and Design Department at Frome College, Somerset; Postgraduate students at the University of Bristol School of Education and the Bristol Polytechnic School of Art Education; students at the College of St Paul and St Mary, Cheltenham; pupils in comprehensive schools in Avon; Cranks Restaurants; the Bodleian Library, Oxford; Trinity College, Dublin; the Corps of Commissionaires; the British Museum; the Lilley Library, Indiana University; the Metropolitan Museum of Art, New York; A C Cooper Ltd, London; the British Library; Hereford Cathedral; the Ashmolean Museum, Oxford; Trinity College, Cambridge; the National Museum of Wales, Cardiff; Cambridge University Library; and the Metropolitan District of Wakefield in Yorkshire.

Finally I should like to express my gratitude to Jane Birch for her invaluable help in typing the drafts of the manuscript from my many indecipherable scribbles.

J L
Cheltenham 1980

Introduction

The basic idea for this book resulted to a great extent from my experience of lettering, albeit script-lettering, at school when my art master gave me a penholder, square-ended steel nib, a small brass reservoir, a bottle of ink and some paper and told me to write — the quick brown fox jumps over the lazy dog — in what I now regard as a rather clumsy script. Of course I was not the only sufferer, for every boy in the school — from the first to the sixth form — was subjected to the same ordeal and we all copied, like kindred spirits, this all-letter-embracing sentence. I remember quite vividly that it was written in dark blue or purple on a yellow chalkboard so that it was extremely legible, and it etched itself deeply into my subconscious. After two or three lessons of tortuous effort, that is for the majority of the pupils, but surprisingly not for me for I seemed to have a certain amount of natural calligraphic talent, a poem in script lettering appeared on the adjacent blackboard in our artroom 'scriptorium'. This we also copied, seemingly with increasing skill and when our art teacher was satisfied with our accomplishments we were then permitted to illuminate our poems with finely drawn borders of ivy-leaf decoration straight out of a fourteenth-century French book of hours.

This procedure was repeated each spring term for five years, to my own knowledge, but as adolescents, captive in school, we never questioned this as pupils might today. We were expected to follow our instructions carefully. What is more, we were not shown examples of medieval manuscript work, neither did we relate our efforts to those of modern calligraphers. The method we were subjected to was that of copying in a mindless and time-filling way which I would compare with therapeutic knitting, to prepare us, in part, for passing the School Certificate Examination in art. I can only agree that my own talents with pen and ink proved of some value in this direction.

The reader will now appreciate that my fascination with lettering is a factor which has contributed to the writing of this book : a factor which also carries over from my art college days. On going to the City of Leeds College of Art (an institution of Henry Moore, Barbara Hepworth, Ivy Benson and Frankie Vaughan fame) I became a student of Thomas Swindlehurst — known affectionately as 'Tommy' by those close to him — who had studied at the Royal College of Art under that famous designer and craftsman, Edward Johnston. Johnston had revived the craft of lettering and illumination, and was responsible for stimulating a vast interest in this subject earlier this century. He was, indirectly, a strong influence upon my own approach to the subject. Indeed, his book *Writing and Illuminating and Lettering* (re-published by Pitman in 1977) became a source of instruction and reference, and recently I was privileged to review it for an educational journal.

Complementing my training as a student of writing, lettering and illumination was a course on letter-cutting and memorial design. This was concerned with the design and carving of inscriptions in stone, slate and wood, and I must admit that although I made many painful attempts to draw and paint classical Roman letters based principally on those on Trajan's Column in Rome, it was not until I had a hammer and chisel in my hands that I understood — almost miraculously — their form and construction. An incised letter isn't to be drawn with pencil or brush, it is a thing to be carved. So, my calligraphic training was enriched by memorial design work, with both aspects strengthening my developing expertise.

My art college period of education was focused on the production of well-proportioned letter forms within the concept of an overall design, and I also studied historical aspects of the subject. It is not surprising, therefore, that when I moved into teaching I decided to use a similar method. After all, it was the thing to do, and my first course of action was to try to teach secondary modern school pupils how to write a formal script with a square-ended pen. I introduced models based upon Winchester tenth-century hands, on reflection a ridiculous mistake, and I should not have been surprised when my pupils had little, if any, interest. Few of these young people were actually capable of handling pens and black ink without making a mess of their pages of writing. To their way of thinking it was not art but an extension of their English lessons, and they resented this. I struggled on, spending a great deal of time demonstrating how letters should be constructed, as well as painstakingly showing individuals how to plan pages of writing; but the children quickly became disenchanted, while I became frustrated and blamed them for my own inadequately considered teaching. I had to re-think my approach and decided that lettering should become a pure art experience. How could I capture and then retain the interest of young adolescents in this aspect of the visual arts, I asked myself? Should I teach the subject in a formal manner? Would it be better if lettering, as part of the art syllabus, were geared much more to the actual interests of young people? Ought I to start off in an experimental way?

Such questions as these have remained with me in my career in schools, colleges and university and, indeed, the very conception of this publication owes much to the experimental approaches to pattern-making, design work and lettering of all kinds which after my initial disastrous efforts I have encouraged my students to employ. I have never failed to be astounded at the interesting, varied and lively work which results once the initial barrier, echoed in the oft-spoken exclamation 'Oh! I cannot possibly do any decent lettering', has been overcome and the students have been encouraged simply to be inventive. Indeed, it is a never failing source of wonder and delight to observe how quickly secondary pupils, specialist art students and even amateurs develop personal skills, a sound grasp of craftmanship, and a competence which took me years, not weeks as in their case, to achieve.

I cannot be certain that this book will help you, the reader, to make similar achievements, for without the actual physical presence of a teacher this might be a little more difficult. My aim is to try to provide as much stimulus as possible, and to do this I shall present you with a number of ideas and suggestions. It will then be up to you to obtain some materials, roll up your sleeves and have a go. Be prepared to make mistakes, however, possibly in profusion, for mistakes are inevitable and must be accepted philosophically as part of any learning process. Mistakes can, after all, be recognised, reflected upon, and then used as an invaluable springboard for developing more skill and understanding.

There are numerous books on lettering and I shall make use of a number of these, as well as providing what I hope will be useful list of such references on page 140. Many books on this subject, however appear to me to be much too technical in concept, and their sophisticated approach is often off-putting. What I intend this book to do is to encourage you simply to have fun and although some critics might accuse me of being flippant I shall insist that you enjoy yourself. Start by doing some throw-away, experimental lettering with unlikely techniques. In doing this you will gain a relaxed and easy confidence so that you are then ready to try out some traditional skills. After such an experimental beginning you will certainly have acquired a basic understanding of the subject and will have a deeper insight to assist your further involvement.

Let me return briefly to an earlier point, for it ought to be said that in my own training at art college I was taught strictly within traditional and technically correct subject boundaries. My fellow students and I were not permitted the freedom for experimentation which I advocate. Rather, we were expected to conform to a rigid, prescribed way of working in which we studied and laboriously copied historical and modern alphabets.

It is certainly not surprising that we all became very adept at drawing and painting Gill Sans forms and in producing Edward Johnston-esque calligraphy which was virtually indistinguishable from that which 'Tommy' insisted upon. Even our italic handwriting tended to be identical to 'Tommy's' own for we felt it was the correct *modus operandi*. Conformity, not individuality, was the key to success, and my reaction has been to say to my own classes 'Make a mess and don't be afraid, for everything you do will be right. You can do nothing wrong.' This approach seems to relax students, putting them in a good frame of mind so that they are immediately receptive to ideas and suggestions. This method is linked with my own exploits into tachist action-painting on large canvases, a release mechanism for me, and it helps students to shed their inhibitions so that they gain, rather than lose, interest.

So, join me in a thrilling adventure of discovery and creative activity. By all means read books on lettering, as many as you can lay your hands on, but please balance your theoretical and philosophical studies with practical involvement, for intensively experienced involvement comes before theory. Personal involvement and first hand experience cannot be bettered. Persevere and you will be delighted with the range of skills you acquire. At least, that is my hope. Look at the countless examples of medieval and other lettering to be seen in museums, some of which have been used as illustrations to this text, and visit such places of interest as the British Museum, the Bodleian Library in Oxford, the Fitzwilliam Museum in Cambridge or the Chained Library in Hereford Cathedral. Go to local museum and cathedral libraries near your own home. Look around a churchyard or two. You will certainly have no difficulty in finding examples of modern, pop-art lettering in magazines, on the cinema or television screens, in the kitchen, in the high street, on road signs, on toffee papers and packages of all kinds, and you might even take an interest in the visual idiocy on many a tee-shirt front.

I want us to go along together and to keep a spirit of adventure alive. We can be inspired by the simple illustration by a four-year-old boy who overhead me talking about this book with his father. 'I will do some lettering for your book, Uncle John', he said, and sure enough, two or three days later I received through the post a number of lettering designs done for me with felt-tipped pens. Overleaf is one of Adam's pieces of work and it points us to the path we should follow — that of the bold,

uninhibited practitioner. Be bold, be adventurous, be inventive, and throw caution to the winds. Look around and you will be amazed at what you will see.

In this book I have also tried to balance the experimental approach with more serious work and in doing so I have emphasised calligraphy rather more than other aspects. In a book of this kind one has limited scope and as the field is so vast I had to be selective, concentrating upon a number of areas to the detriment of others. But this is to be expected for every section could have been expanded into book form. I have put such separate units together in what might appear to the critic as a rather awkward juxtaposition which includes a sketchy historical overview and, to give a personal flavour, some examples of the work of two modern designers that I know and respect.

My reliance on a mass of visual material is deliberate. In the early stages I assured my editor that I wished to work in this way, with illustrations and captions taking the place of an elaborately written text since the majority of those interested in the visual arts like to see visual things. Vast quantities of text are not for them perhaps and not for you either, so I am following the dictates of the artist and assume that this will be appreciated.

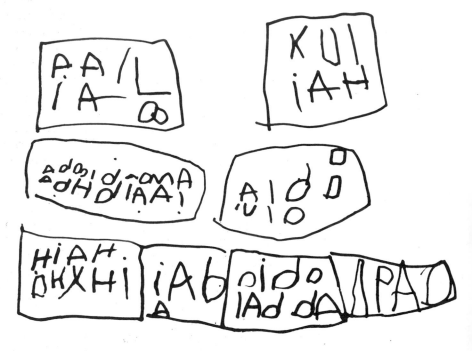

Historical overview

The history of lettering — which I shall define simply as the
interpretation of human speech through symbolic visual
imagery — is a vast, confused and complicated field of study,
and in putting this section together I have realised increasingly
that it will only permit me to skim the surface. I have therefore
attempted to condense it into as concise and simple a diagram-
matic form as possible so that it is easy to follow. My intention
is to present an overview so that you, the reader, will easily
relate a number of chronological sequences and important styles
and developments. If you wish to study this in more detail you
will find Donald Anderson's book *The Art of Written Forms:
The Theory and Practice of Calligraphy* (Rinehart and Winston)
an excellent one for this purpose. It is a scholarly text and it
has a comprehensive set of notes and references. *The Story of
Handwriting : Origins and Development* by Alfred Fairbank
(Faber and Faber) though much simpler in style and concept, is
also informative and should have a particular appeal to the
younger reader. These and other reference sources are to be
found in the bibliographical section listing useful lettering
books on page 140.

Letter forms have been modified a great deal throughout the
long period of their development and these carefully considered
graphic images, used by man to articulate language sounds, have
catered for the visual communicative needs of races and nations.
They certainly reflect the periods in which they were produced,
while the actual materials and tools used in their creation have
influenced them strongly. The tools used by craftsmen include
reed and quill pens; papyrus, vellum and paper; chisels for
carving wood, slate, marble and stone; wooden and metal type
in printing; tools for engraving metal printing plates and glass;
typewriters for office use; fountain pens, pencils, ball-point
pens and felt-tipped pens for the speedy execution of modern,
scribbled cursive or for dictated shorthand; photographic
reproduction methods, and 'instant' lettering of many kinds
which is so easy and quick to use that little effort or crafts-
manship is required. There may be others which I have missed
from this list but it does cover the main categories.

In Chart A I have selected eight letters so that changes in their
development, from the fourteenth century BC to the present

day, are easy to see. The sketches of square-ended (chisel-edged) and oblique-angled pens should enable you to appreciate the influence of these writing implements upon lettering styles; while the other charts are designed to span the history of lettering simply and concisely, making an expansive text unnecessary.

The development of lettering (Chart B) falls into two broad groupings: picture writing (pictograms and ideograms) and phonography (best described as full-writing). Phonography actually developed in two directions: eastwards to produce Chinese pictographic imagery; and westwards where it gave rise to Egyptian, Etruscan, Greek, Roman and other forms which we use in the Western world today. Chronological charts 1 and 2 illustrate these groupings clearly, with the various phonographic styles placed in an approximate chronological order in subsequent charts and with illustrative material related to them. These charts are:

Chronological chart 3 Egyptian (three main scripts)
Chronological chart 4 Roman (Greek and Etruscan are
 excluded here)
Chronological chart 5 early medieval
Chronological chart 6 middle medieval
Chronological chart 7 late medieval
Chronological chart 8 Renaissance (including the
 Humanistic minuscule or italic, and the birth of printing)
Chronological chart 9 Seventeenth, eighteenth and
 nineteenth centuries
Chronological chart 10 modern.

Much of the lettering in use throughout the twentieth-century Western world is derived from classical Roman forms, whose practical characteristics and proportions have remained virtually unaffected throughout the centuries. In the Italian Renaissance of the fourteenth to sixteenth centuries there was an increased interest in beautiful handwriting and italic cursive was developed by the Humanists. This style has been fed down to us in the twentieth century and present day lower-case printing is a direct result of this style.

Chinese and Japanese logographic scripts (a logograph is a symbol for a word whereas an ideograph is a symbol for an idea) really demand an exhaustive study. It is impossible to do so in this book but the Chronological chart 11, Chinese (and Japanese) gives a brief overview. This is augmented by a small section towards the end of the book (page 123) — really a taster — to encourage you to take an interest in a fascinating art form through further personal study.

Where writing originated

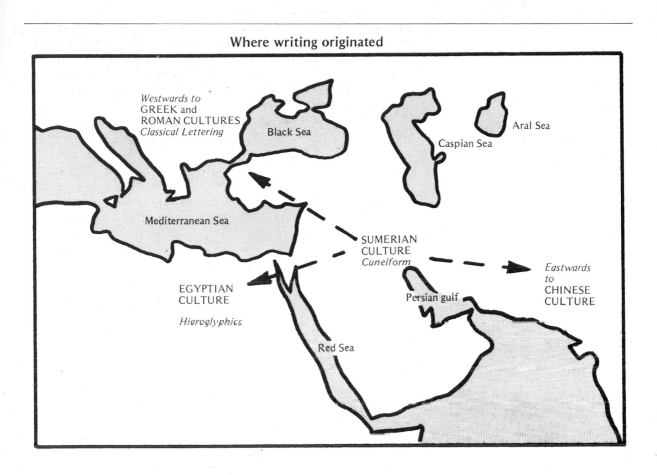

Westwards to
GREEK and
ROMAN CULTURES
Classical Lettering

Black Sea

Aral Sea

Caspian Sea

Mediterranean Sea

SUMERIAN
CULTURE
Cuneiform

EGYPTIAN
CULTURE

Hieroglyphics

Persian gulf

Eastwards
to
CHINESE
CULTURE

Red Sea

Chart A — Developmental comparison of eight letter forms: fourteenth century BC to twentieth century AD

Semitic Phoenician 14th c. BC.	Derivation	Greek 13th c. BC (?) 9th c. BC (?)	Roman 7th c. BC	Square capitals	Rustic capitals	Uncials Pre 4th c. AD	Half uncials 6th c. AD	Carolingian Miniscule 9th c. AD	Modern scripts 20th c. AD	Modern type faces 20th c. AD
A	oxhead or cowshead	A	A	A	A	A	a	Aaa	A A a	A A a
B	house or courtyard	B	B	B	B	B	b	Bb	Bb b	B B
D	door or entrance	D	D	D	D	D	d	Dd	Dd d	D D a
F	nail or hook	F	F	F	F	F	f	Ff	f f	f f F
L	oxgoad or whip	L	L	L	L	L	L	LL	L L	L L
M	water	M	M	M	M	M	m	Mm	M m m	p m
P	mouth	P	P	P	P	P	p	Pp	Pp p	p P S
S	mountain or hilltops	S	S	S	S	S	S	Sf	S s s	S S S
Chisel Incised in stone and clay *also* painted on pottery	Developed from Pictograms and Ideograms	Chisel Incised in stone Pen after 5th century written from left to right	Chisel Incised in stone Pen earliest pen M.S. 3rd century BC	Pen — Reed & quill	Pen — Reed & quill	Pen — Quill	Pen — Quill	Pen — Quill	Pen — Quill, steel nib and fountain pen	Mechanical Roman, Sans-serif, ornamental Type-faces (many and varied) Instant lettering (many and varied)

14

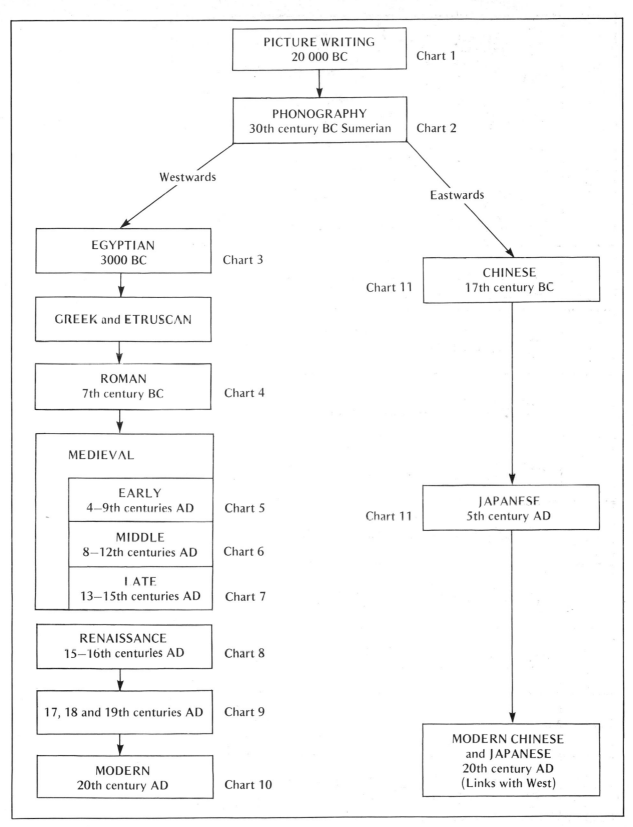

Chart B — The development of lettering — this diagram should
be seen in relation to chronological charts 1—11

Chart 1 — Picture writing

PICTOGRAPHS or PICTOGRAMS	Pre historic cave paintings, drawings, etc (2 000 BC) Picture writing — basically realistic drawings and paintings, some of which tend to abstraction — conveying meaningful ideas
IDEOGRAMS	Movement away from pictures to the graphic representation of ideas

VISUAL SIGNS REPRESENT HUMAN UTTERANCES
WRITING LINKED WITH SPEECH

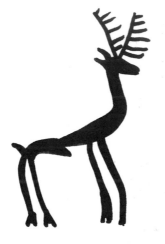

Hunter Drawing of a deer Semi-representational drawing of a group of three women — Valltorta, Africa — Palaeolithic Basic prehistoric picture writing

Pictograms and ideograms

Fish

Sun

Threshing sledge (2600 BC) pictogram

Duck

Horse

Foot (2600 BC) pictogram Hand (2600 BC) pictogram

People

Sign for weeping — ideogram

Modern ideograms 1979

Chart 2 — Phonography (full writing) gradually developed

SUMERIAN	The first phonetic system — first written language (pre- 3000 BC) Cuneiform — wedge-shaped letters	
EGYPTIAN ←	Southern Mesopotamian influences moved WEST and EAST →	CHINESE
GREEK ETRUSCAN ROMAN	(Mediterranean and Aegean areas) CLASSICAL FORMS Square Caps Rustic	JAPANESE
EUROPEAN and now WORLD WIDE	Medieval scripts Uncials Half-uncials Carolingian Gothic 'black' letters Printing Lettering today	

Etruscan letters circa eighth century BC

Greek letters fifth century BC

Chart 3 — Egyptian

THREE MAIN SCRIPTS
(3000 BC)

HIEROGLYPHICS ⟶	HIERATIC ⟶	DEMOTIC
Monumental images Sacred architectural inscriptions	Derived from and imitated hieroglyphics	A cursive shorthand and
essentially picture writing on stone	a cursive writing produced with brushes and reed pens on papyrus	a quick writing style (7th century BC)
	vertical columns which changed to horizontal left-to-right	reed pens

The Egyptians were responsible for making writing available to ordinary people such as traders and merchants, and therefore extended it from the previously closed domains of the priesthood and ruling classes.

An interesting example of Egyptian writing freely copied by a young student studying the history of lettering from a photograph of an eighteenth-century BC Dynasty fresco in Thebes

Stone tablet showing cuneiform lettering. Sippar, ninth century BC Reproduced by courtesy of the Trustees of the British Museum (Ref. E 2056 WA5)

19

Chart 4 — Roman (derived from Greek)

CLASSICAL ROMAN	Lettering incised in stone (7th century BC)
SQUARE CAPITALS	Formal lettering (Quadrata Tituli) used in important manuscripts
RUSTIC CAPITALS	Informal Roman letters (Scriptura Actuaria) used for posters and wall notices, such as those at Pompeii, were written quickly. (Used up to 500 AD.)

Incised Roman lettering second century AD based on pen- and brush-made forms and characterised by an incised V-section carved in stone or marble. The letters have elegance and majesty and have had a great influence upon later forms

BLRO NG

Square capitals — pen held or cut to produce thin vertical and thick horizontal strokes

ABCDEFGHILMNOPR STV Q

Unicials — pen angles tended to vary

ABCDEFGHI MNOPQRSTUX

Rustic letters — the angle of the pen remained constant at an oblique angle

ABCDEFGHILMNO PRSTVY

Chart 5 — Early medieval

UNCIALS	(4th—9th centuries AD) A new and graceful writing style developed in European scriptoria. The letters had a basic dignity and were characterised by roundness of form. Descenders and ascenders appeared and letters such as 'M' and 'E' became rounder
HALF-UNCIALS	(6th—9th centuries AD) Roman half-uncials developed from majuscule letter forms which were gradually modified as the scribes speeded up their writing Half-uncials marked the change from capitals to small letters Irish Majuscules (half-uncial letter forms with triangular serifs) were based on Roman scripts taken by missionaries to Ireland. In the 7th century they were of unsurpassed beauty and the *Book of Kells* shows clearly the high degree of technical skills acquired by the scribes English Insular Majuscule was written in England (see Lindisfarne Gospels, British Museum, which contains half-uncial scripts which are the equal of Irish hands)

An example of insular minuscule page from an eighth-century manuscript which is divided into two parts, 67 leaves in Cambridge and 5 leaves in London. This photograph is from the Cambridge part Reproduced by courtesy of the Master and Fellows of Trinity College, Cambridge *(Ref. Trinity College B.10.5 upper part of fol. 20R)*

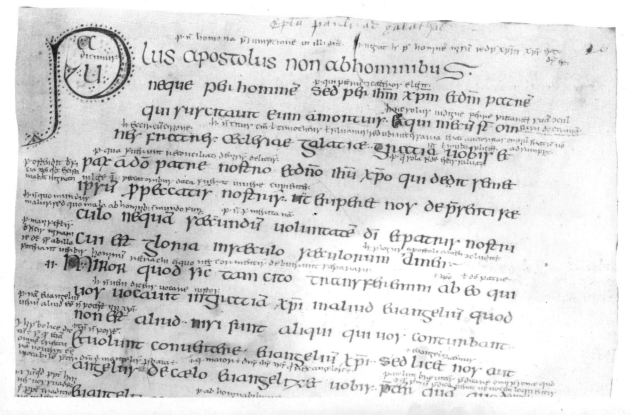

An example of uncial lettering seventh/eighth centuries with pen held either vertically or cut obliquely to produce thick vertical and thin horizontal strokes Reproduced by courtesy of Cambridge University Library *(Ref. CLA II 138 MS kk. 1.24)*

It is interesting to see how this fragment of uncial writing has been preserved by being stitched to a larger page of vellum. This was done, apparently, prior to its arrival at Indiana University in 1958. Reproduced by courtesy of the Lilley Library, Indiana University, USA *(See Poole ms 65 seventh and eighth centuries, Italian. Bond and Fay Supplement to the De Ricci Census, 1962, pages 182-183 Bodleian Library, Oxford, CLA II 145 uncial)*

The beginning of the Genealogy of Christ from St Luke's Gospel, eighth century, from the Book of Kells, folio 200 v. Reproduced by permission of the Board of Trinity College, Dublin

22

factus est tu es filius meus dilectus inte
bene complacuit mihi

Et ipse ihs erat incipiens quasi an
norum triginta ut putabatur filius
ioseph

VI	fuit	heli
VI	fuit	mathat
VI	fuit	leui
VI	fuit	melchi
VI	fuit	iamne
VI	fuit	ioseph
VI	fuit	mathat hie
VI	fuit	amos
VI	fuit	naum
VI	fuit	esli
VI	fuit	hagge
VI	fuit	mahath

uidit illum discipulum quem diligebat
ihs sequentem qui et recumbuit in cena
super pectus eius et dixit ei quis est dne
qui tradet te hunc ergo cum uidet petrus
dicit ihu dne hic autem quid erit dicit ei
ihs sic eum uolo manere donec ueniam
quid adte tu me sequere ⁖ Exiit ergo
sermo iste inter fratres quia disci
pulus ille non moritur et non dixit ei
ihs non moritur sed sic uolo eum ma
nere donec uenio quid adte hic est dis
cipulus qui testimonium perhibet de his
et scribsit hec et scimus quia testimonium
eius uerum est Sunt et alia multa
que fecit ihs que scribentur per singula
nec ipsum arbitror mundum capere
eos qui scribendi sunt libros ⁖ finit amen ⁖

Her swutelað on ðissum gewrite þæt scire gemot sæt
æt ægelnoðes stane berhtuces dæge cingeres þær sæt oð
æþelstan biscpang ealdorman. Eadwine þær aldormannes
leofwine pulfiges sunu bu þæcill hpita. geodfryð preoda comfen
order cinger æpende. þær pær bruning scirgerefa. æþelgar
æt þonie. leofwine æt þonie. godric æt pede. ealle þa
þegnas on herefordscire. þacom þær fariende toðan
gemote. eadpine enneaþnes sunu. þrpæc þar on hiðagene
modor æfter rumpendæle landes. þær peolintan
scirdegnen ... þa acpode sebiscpoþ hpa sceolde and
swarian fo rhis moder. þa spreopode þupeill hpita.
grade þ herceolde gif he ða talu cuðe. þa he ða talu nane
cuðe. þa sceapode man þreo þegnas of ðan gemote.

Insular majuscule in a manuscript written in an English scriptorium under the Celtic influence — probably a centre near the Welsh border. It has an eleventh-century record in Anglo-Saxon vernacular referring to places in the county of Herefordshire and two convents in Hereford. Reproduced by courtesy of the Dean and Chapter of Hereford Cathedral Library *(Ref. MS Hereford Pi z CLA II 157)*

Chart 6 — Middle medieval

CAROLINGIAN MINUSCULE and 10–12th century derivations	(8th–12th centuries AD) The Carolingian Minuscule (often referred to as Caroline Minuscule) was the result of Emperor Charlemagne's great revival of learning and writing reforms in French monasteries. This writing hand was developed by Alcuin — who had been in charge of the York scriptorium in England — at Tours, and influenced developments in Europe. It is a graceful and legible style, developed from Roman half-uncials, and the letters are joined. They are as round as half-uncials and the ascenders are thicker at the ends. The more slanted pen letters of the 10th century tended to be compressed slightly and this meant that they required less space. Indeed, this lateral compression became more pronounced in the 11th and 12th centuries, with the pen letters gradually becoming angular. With the introduction of the *Gothic*, or 'black' letter, curves were replaced by angles and straight lines.

aeuobiretpm

Carolingian minuscule

angeli dni furoq pte

tenth century

quaeco bmurx

eleventh century

urgenafqslod uniumilos;
magnam inea filiu

twelfth century

Decorated initial letter from a twelfth-century Bible in blue, orange-red, red, green and gold. Reproduced by courtesy of the Bodleian Library, Oxford (Ref. MS Auct. E Infra 1 (S.C. 2426) f 264ᵛ)

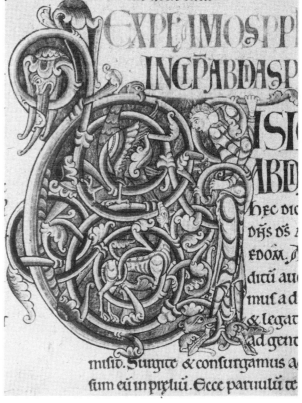

Chart 7 — Late medieval

BLACK LETTER Gothic, Old English	(13th–15th centuries AD)
	The condensed character of Gothic lettering led to the name Black Letter. There was an increasing tendency to compress the letters, making them much more angular and square, with the result that more could be fitted onto a line. Towards the 15th century they became more elongated and writing lost much of its previous legibility, becoming much more decorative and giving an overall 'blackness' to a page.

Thirteenth-century Black Letters

Versal letters

Fourteenth-century Black Lettering and versals

Fifteenth-century Black Lettering with decorative Lombardic capitals

Lettering in the Gothic or Black Letter style printed in 1456 by Gutenberg. This example is from his 42-line Bible

Chart 8 — Renaissance

ITALIC	(15th and 16th centuries AD)
Humanist minuscule	Italian Humanist scholars were influenced by 11th and 12th-century manuscripts and the Carolingian scripts. A new Humanistic minuscule was created which eventually became the basis for our modern lower-case
	Classical Roman inscriptions were studied and pen-made capital letters were developed by Bracciolini, one of the Humanists, which were complementary to minuscule letters
	Humanistic writing developed into the Italic script — used in letters and Papal documents — and it combined speed, legibility and beauty of form
	Book production increased because of the use of vernacular languages and wealthy patrons employed vast numbers of scribes
	When, in 1509, Henry VIII became King of England a chancery cursive (italic) became popular
	The construction of classical inscriptional letters was studied and new alphabets were designed
PRINTING	Invented in Germany in 1450 and spread rapidly throughout Europe. It led to new techniques in book production and an increase in the use of paper
	The first printed books aped written manuscripts
	16th-century writing manuals were produced in considerable numbers by many writing masters such as Arrighi, often with cumbersome letters, copper-plate intaglio methods and the printing of very fine, intricate work. Fine-point engraving and 'round' penmanship resulted in Baroque italic forms characterised by thick and thin strokes. The writing masters competed in producing complex geometric designs with incredible skills, and many new alphabets were designed
	Relief printing (wood and metal) and the development of moveable type from earlier experiments by Gutenberg in the early 1440s
	Intaglio, lithography, collotype seriography were developed and today we also have quick, cheap photocopying in general use
	Caxton introduced printing into England in 1477

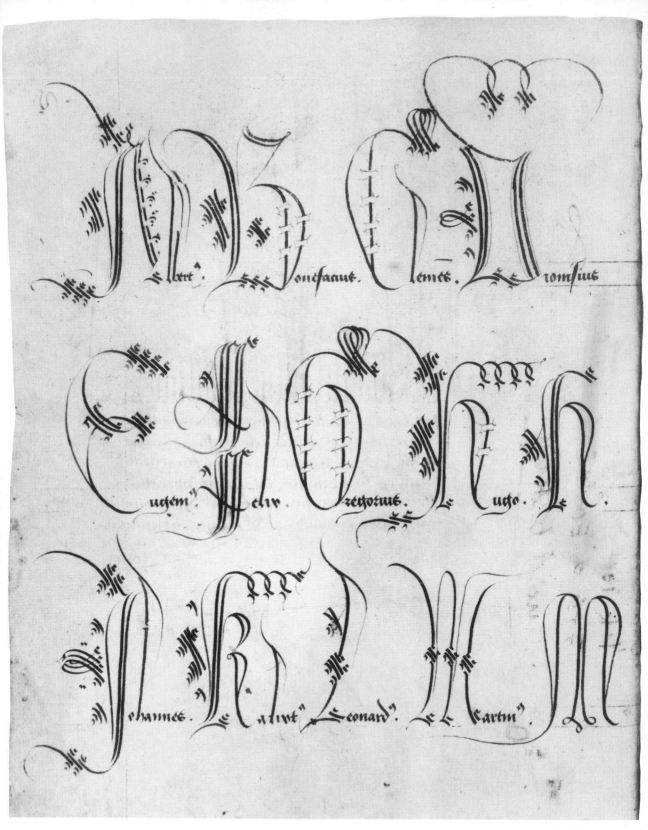

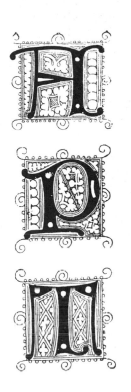

Printed initials — sixteenth century

Fifteenth century, British School
Reproduced by courtesy of the
Bodleian Library, Oxford *(Ref. MS
Ashmole 789 fol 3ᵛ)*

Chart 9 — Seventeenth, eighteenth and nineteenth centuries

VARIETY OF LETTERING STYLES	(17th—19th centuries)
	A period of relative calm following the incredible vitality of the Renaissance and there were few real developments
	Type-design was affected by advertising early in the 19th century ie Baskerville, Bodoni-Didot or Modern Roman, Square-serif or Egyptian
	Introduction of Sans Serif lettering — letters without serifs and all the same thickness — by Caslon in the 1840s
	Newspapers and magazines took the printed word increasingly into the homes of ordinary people
	Proliferation of decorated and ornamental alphabets after 1850
	Printing and art and craft revivals at very end of the 19th century — Morris and Ruskin — and these influenced early 20th century ideas as well as counteracting low artistic standards

Early eighteenth-century lettering incised in slate showing the influence of copper-plate, fine-point engraving

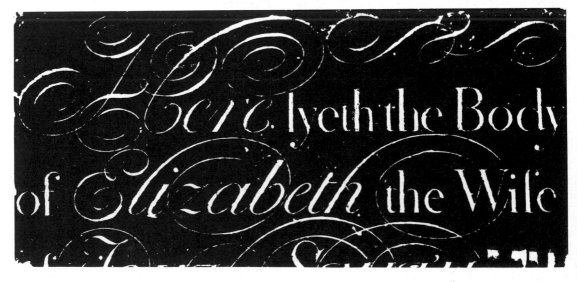

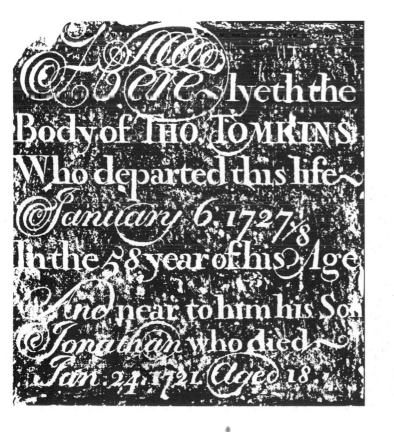

A charming headstone at Burton Overy, Leicestershire, obviously carved by a local craftsman — early seventeenth century. You can learn a great deal about letter-design from such examples. Photograph by Hugh Collinson

Rubbing of incised lettering at Thurcaston in Leicestershire. Photograph by Hugh Collinson

Rubbing taken from incised numerals on a tombstone. White wax was used and the photographic effect was then obtained by brushing black ink over it

Caslon Old Face (1734) was designed by William Caslon. It is a lovely typeface and still sometimes used

abcdefghijklm
ABCDEFGHIJ

Local churchyards are goldmines when you are seeking examples of carved lettering

Chart 10 — Modern

BEWILDERING CONFUSION OF PRINTING STYLES	(20th century AD)
	Many new alphabets have been introduced in this century
	Printing revivals saw the establishment of numerous private presses at the end of the last century and William Morris established the Kelmscott Press in 1891, for which he designed three type founts, and there were many others in England, Europe and North America
Roman Sans-serif Ornamental Black letter Computer images	Mass production — newspapers, magazines and books — now caters for an incredibly vast, literate market and production methods change even as I write.
	Advertising plays an ever-increasing role in which many forms or styles of lettering flourish
CURSIVE	Writing revivals earlier this century were led, in the United Kingdom, by Edward Johnston. He based his calligraphy on Carolingian and 10th-century writing hands, and spearheaded a teaching revolution
Italic Modern scripts Fountain pen Copper plate Ball-point scribble	Eric Gill, a student of Johnston's, designed incised stone alphabets and type-faces (Perpetua — 1925, and Gill Sans — 1927). The effect of his work is now widespread
	Other important figures include Koch, Zapf and Simons (Germany) and Goudy, Rogers and Dwiggins (USA)

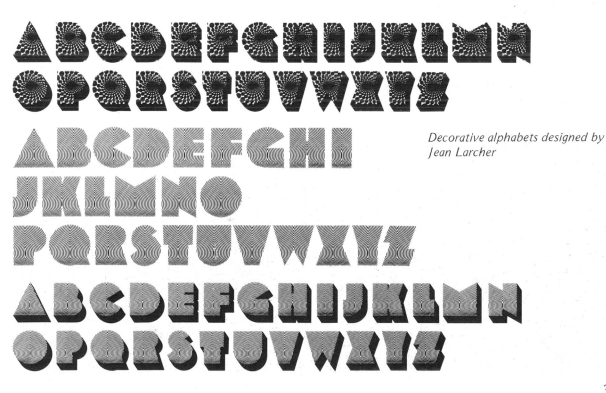

Decorative alphabets designed by Jean Larcher

33

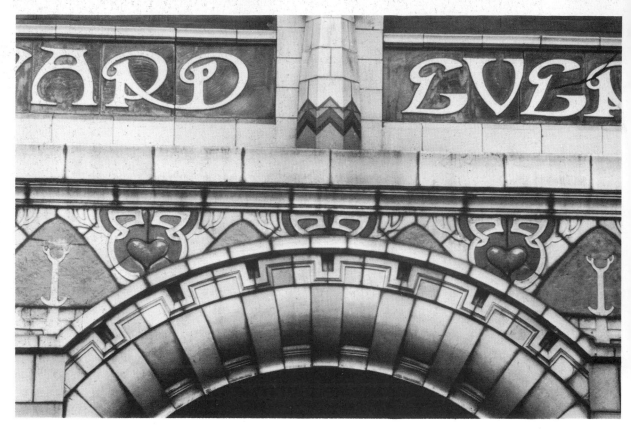

Art Nouveau ceramic lettering,
Bristol

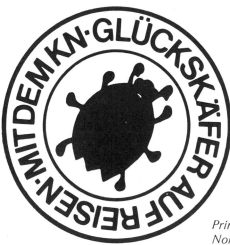

Printed table reservation from a
Norwegian restaurant, 1979

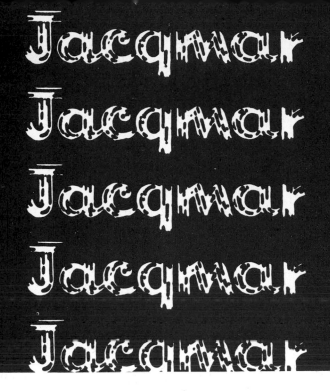

An example of twentieth-century advertising

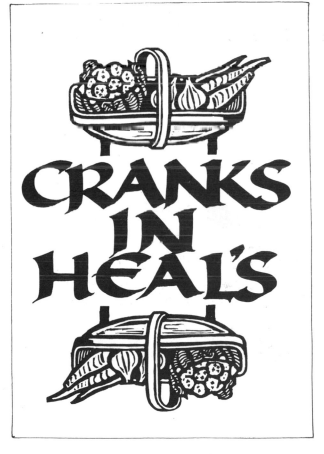

A printed menu cover based upon a modern script, 1979

Chart 11 — Chinese and Japanese

LETTERING	(1700 BC)
	Six traditional categories
	1) pictographs 2) simple ideographs 3) compound ideographs 4) phonetic loans 5) phonetic compounds 6) derivative characters
	(See *Encyclopaedia Britannica* 'Chinese Language')
	Monosyllabic, salligraphic symbols have been employed and calligraphy is considered as a high art form conveying (1) thoughts and (2) the beauty of thoughts
	Pictographic origins have developed into ideographic images done with a brush and black 'chinese' stick ink
	These brush-made images are done with few strokes, with the brush held vertically on a flat writing surface, and are closely related to painting
	Each calligraphic character — produced within the framework of a square — represents an idea
	There are two basic Chinese forms — MANDARIN and CANTONESE, and the lettering is done in vertical columns, moving from the right to the left of the page. Western influences, however, have introduced a horizontal arrangement
	JAPANESE forms developed from Chinese in the 5th century AD
	Printed forms have been derived from calligraphy with some 20th-century type faces designed to relate with western Sans Serif

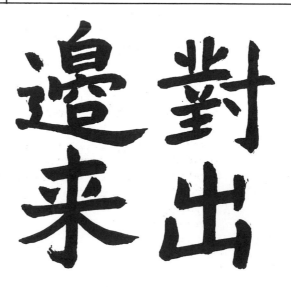

Lettering in adolescent 'vandal' art

In 1925 Martin Buber, the eminent German philosopher, said that every human being has a compelling urge to be inventive, and that he posseses an 'originator instinct'. (Note 1.) It is obvious, however, that in our modern, fast-moving and technology-dominated society young people get few opportunites to put their creative instincts into practice. In order to express themselves they often resort to what society in general sees as vandalism. You only need to walk along some backstreets in every town or city in the land to find evidence of the adolescent's maltreatment of the everyday environment.

Walls, doors, windows and gates in the vicinity of football stadia are particularly vulnerable and yet the examples of what I shall call spray-paint art, shown here, often termed as 'graffiti', have a dynamism that is extremely rich. They display an intense joy in mark-making, although they have resulted from a sense of frustration and revolt against the norms of society. I find such creativity exciting, although I cannot, nor would I, condone such wanton destruction of property and often wonder why this youthful, effervescent energy is left to evaporate instead of being used creatively for the good of the local environment.

A postgraduate student of mine at the University of Bristol was very interested in this form of graphic art, and in making a study of it took some of these photographs near a large football club in a city in the North-East of England. He was excited by the possibilities of spray-paint art in teaching and discussed this art form with some of his pupils in a comprehensive school in Avon. The outcome was that small groups of pupils used aerosol paints to design and execute quite large wall murals in the school, in which letters were used as a basis. The pupils worked on a much larger scale than usual, had a lot of enjoyment, learnt something more about colour and pattern, and certainly became quite skilful in using aerosol colours. They were, in effect, producing abstract paintings but, more importantly, their interest in art work and their appreciation for well designed lettering and layout certainly increased and therefore justified this experience.

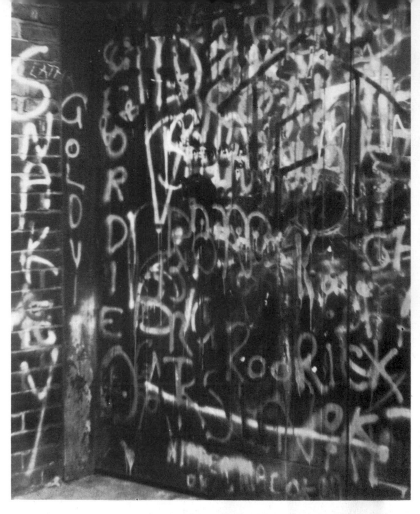

The photographs in this section
are by Peter Rock

*A door photographed at a football
stadium which has attracted some
adolescent attention. It is interest-
ing to see that both horizontal and
vertical planes have been used,
which demonstrates a basic concern
for graphics*

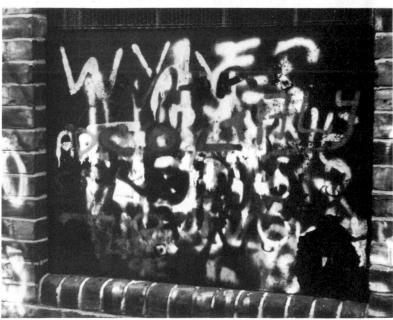

*Although the visual effects achieved
on this metal panel (it actually pro-
tects a window) are purely acciden-
tal, there is no doubt at all about
their virility. Indeed, it could easily
be removed, framed and displayed
in a gallery of modern art where the
majority of observers would accept
it as a colourful abstract painting*

Ideas for practical work

I would not suggest that any of us should go around vandalising walls and fences in our local environments, for this would be irresponsible in the extreme, although I have often thought that many citizens — young and old alike — would welcome a chance to let off steam while, at the same time, being creative. How interesting it would be, to have a specially constructed wall in the middle of a shopping precinct where spray paints could be used by ordinary people as a means of expressing their feelings. Periods of time could be set aside each week for creative expression, with an attendant to supervise, and provide protective clothes and materials. In this way we would have a constantly changing work of art in which the citizen could have an opportunity to be actively involved rather than being simply a passive observer. It is an idea -- simple and inexpensive — which could fulfil a social need.

On the other hand some aspiring artists might wish to use spray paints for well considered mural decoration in private homes, offices, shops or theatres. If so, they might find the following ideas useful as a basis for their thinking. Cheap aerosol paints are obviously quite splendid, although they don't last for long, while professional equipment such as that used for re-spraying automobiles is excellent, but you will need the right facilities.

1 Use 'random' lettering (as in the illustrations in this section) to cover large areas of paper, board, canvas or wall-space.

2 A more carefully considered design approach would be to break up the surface to be painted with a basic grid — ie squares, triangles, rectangles, diamonds, vertical lines or horizontal lines, etc — by spraying these on in colour. These basic areas could be hollow or solid and would then lend themselves well as a frame-work for 'sprayed' letters. Think of:

hollow squares and solid letters (black, white and grey)

solid squares (two colours) and 'open' letters (black and white)

a triangular grid and numbers (yellow, orange and red)

a series of diamonds (lozenge shapes) in three tones of grey on which you superimpose brightly coloured letters and/or numerals

3 An interesting method might be to draw a number of large letters onto sheets of newspaper or strong, brown wrapping paper with a large felt-tipped pen and to cut these out. These letters could then be arranged as a pattern — or to form words — on your studio floor, before being transposed to your painting surface (canvas or wall) and fixed lightly with paste, sellotape or small pins. When you are satisfied with the arrange-ment, it should be a relatively easy matter to spray around the cut-out paper letters.

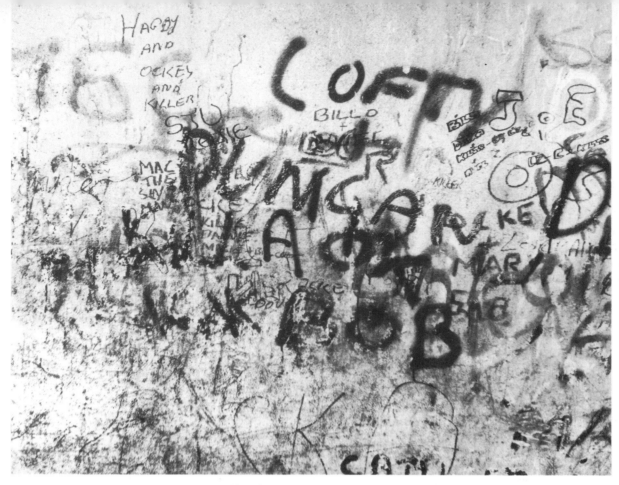

These two examples of football graffiti also demonstrate that young people have a strong, natural urge for self-expression. In other words, they intend, as most artists since the beginning of time, to leave their mark

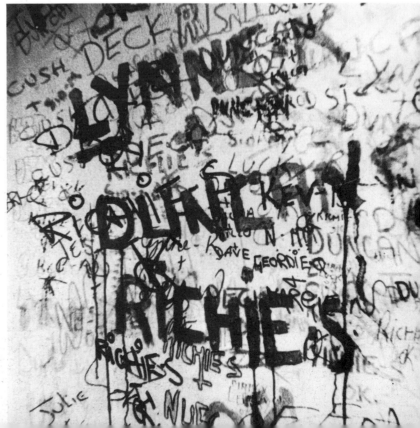

4 Develop idea 3 further by re-juxtaposing some of the cut-out images and over-spraying.

5 Design a large mural-type painting which incorporates collage materials (added paper, card, fabrics, etc). You might even use some of the cut-out paper lettering left over from ideas 3 and 4.

Draw a centre line in pencil or chalk across your painting surface and glue some of the cut-out letters so that they stand on this line. Other letters should then be turned upside-down and stuck down so that they touch this centre line while seemingly hanging below it. Loose paper or card cut-outs can then be used to mask areas of your design while you spray colour on to it. This will call for some experimentation and inventiveness on your part, but it might be wise to consider a limited colour combination.

6 Let us assume that you intend to paint an area of wall space in the entrance hall of a large block of flats. This wall is dark olive green, with adjacent walls in dark red, a fitted carpet of lime green and with a gilt and glass-topped table for magazines or a vase of flowers and two chairs in gilt and red velvet.

The architect's brief to you, as the mural painter, is quite simple:

Design brief
Design a mural based upon a large spiral which starts in the very centre of the wall and finishes in the very top left-hand corner.

The adolescents' love of expressive mark-making has been sensibly channelled here through their art lessons at school by an understanding teacher. In this illustration of a wall at the end of a corridor inside a school an attempt has been made to allow them to express themselves freely while also concerning them with the use of colour, pattern and texture

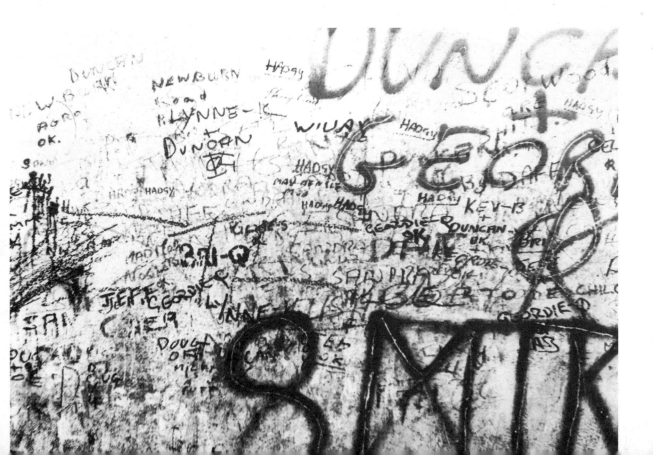

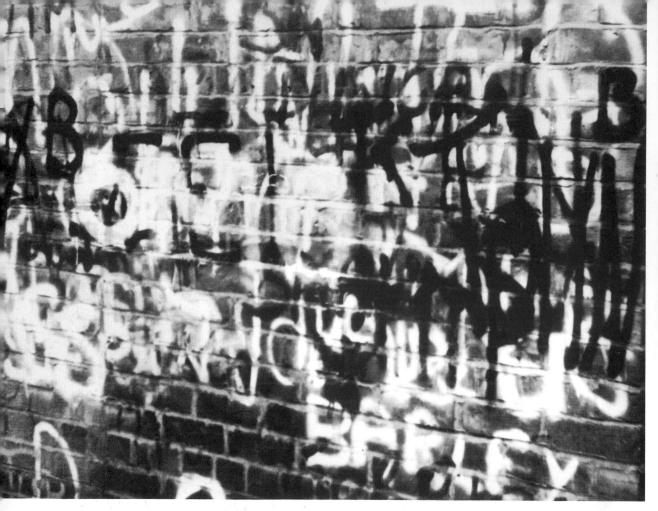

In this instance a rather ordinary, uninteresting brick wall around a school playground was utilised by a an art teacher and a colourful demonstration of youthful exuberance resulted

This spiral, to be done with gold spray-paint, must lend itself as a base for oriental-type letters of a decorative nature in black, bright red and lime green. Areas of solid colour and texture may be added later to parts of the painting.

7　You have been commissioned by a gallery to put on a one-man exhibition of paintings. Each painting will be on canvas 1.83 m square (6 ft square) and framed within a plain, gilt wooden moulding.

The art gallery's brief is:
Each painting should consist of a circle (small or large) from which letters of the alphabet radiate and with some of these actually touching the edges of the canvas. The circles need not be in the centre of the picture space.
You should incorporate both freely sprayed and cut-out letters.
Your colours should be limited to black, white and three colours for each painting.
If you wish, each basic circle could be either of solid paint or have one letter situated within it.

Experimenting with instant lettering

A range of mass-produced, easy to use instant letters is marketed today and sheets of *Letraset, Letrasign, Prestik, Primark* and other makes of self-adhesive lettering may be readily purchased from local stores or newsagents. Some office-supply companies stock a variety of alphabet styles and sizes which are particularly helpful to both amateur and professional designers, especially as this form of lettering can be used quite easily in the production of hand-made notices, posters and signs on paper, wood, metal, plastic or glass, and it is employed extensively by professional designers and advertising agencies. It is a relatively inexpensive product compared with costly printing processes, whose many styles of type it tends to copy, and it has become an invaluable addition which gives a professional flair to graphic design work. It can also be reproduced and is used extensively in film-making by both cinema and television designers.

So, the function of instant lettering appears to be that of a pragmatic communicating agent. However, I see this medium of graphic art lending itself extremely well to purely creative purposes and, as some of the illustrations show, I believe it can be a very potent stimulus to image-making of all kinds.

Basic techniques

Letraset letters are placed face down onto a flat surface such as paper or card and the backs of the selected letters are rubbed firmly with a smooth instrument such as a ball-point pen or even a finger nail. *Prestik* letters are peeled off their backing sheets and as their reverse sides are covered with a self-adhesive they may be arranged and pressed firmly on to a flat surface. *Letrasign* letters are usually larger than the others and are single plastic shapes. These also adhere easily to almost any flat surface.

The illustrations in this series contain one or more of these three kinds of instant letters. I chose black to contrast strongly with the white surface of the card, although some of the letters which appear to be grey in colour were actually red *Letrasign* letters. You will see that in some instances I cut large letters into more abstract, geometric shapes with a pair of scissors and then placed these in juxtaposition with other letters to form

interesting visual designs. This kind of ready-made lettering is exciting to use and you might like to try it out. The following suggestions should be helpful as starting points:

Practical ideas

1 Produce a series of 'mirror-image' designs by simply arranging some letters in two lines with the bases of the letters touching, one line facing one way and the other in the opposite direction.

2 Develop this idea further by composing a few words and using four, six or eight lines of lettering.

3 It might be interesting to introduce some colours or a number of tones into some of your designs by painting in some of the negative areas with a small brush and strong colours. (The letters or letter-shapes are positive).

It can be seen in the illustration that the large letter O has been turned on its side as the most dominant feature. Three letter Ns radiate from it like a crown, and an additional group of small letters have been carefully arranged to complete the effect although at a glance they appear to have been scattered like confetti

In this design three large coloured letters have been superimposed on a number of smaller letters, scattered at random on a sheet of card, to give an exciting effect. A line of the letter S, however, has been introduced to maintain a sense of order

4 Place large, coloured letters on top of black and white letter-patterns in an inventive manner.

5 Another idea might be to use aerosol colours to spray paint thinly over one of your designs so that the whole area of paper is covered. Aerosol paints will dry quite rapidly allowing you to peel off a number of the letters so that you are left with unexpected negative images which will contrast with other shapes in your designs.

6 Go on to experiment freely with such techniques. You might think of basic geometric shapes such as squares or circles within or around which to make your designs.

Two further ideas

1 Designs based on an approach in which instant lettering is used could be employed in screen-printing or lino-cutting. They could form basic repeat motifs in the design and production of wallpaper or printed textiles and although I have no examples with which to illustrate this suggestion it might appeal to a number of readers who specialise in printmaking techniques.

2 Variations in design are endless and as a designer you can use your imagination to good effect. Consider reversed printing, over-printing, diagonal patterns, etc and once again I would suggest that you should be inventive.

The imaginative designer is often excited by accidental effects such as those resulting from the negative left-overs of used *Prestik* sheets. I was certainly fascinated by the unexpected shapes and patterns which resulted after I had removed the majority of letters in my experimental work and these illustrations show that I got a great deal of pleasure just by playing about with these ragged sheets. The negative and positive shapes contrast with each other strongly and the effects which they produce are crisp. I could see this idea employed in poster design or, indeed, as a basis for imaginative design work of all kinds.

Practical suggestions

1 Such left-overs could be used as a basis in the design of posters, greetings cards, calendars, or even to stimulate ideas for use in printmaking or painting. Consider vertical columns as a basis.

2 The ideas which such waste materials are likely to spark off could also take the inventive artist into three-dimensional experiments: ie simple sculpture in card, wood or plastic. Vertical columns could be used as a simple, structural element.

3 Left-over materials of this kind could also be used in ceramic studios; for instance, cast-off *Prestik* lettering sheets could be placed over ceramic forms and slips or glazes sprayed over them before being removed and the pots fired. The range and juxtaposition of design and patterning is quite wide.

In this example, far left, a geo-
metric arrangement has been
achieved by contrasting bold red
and black sans-serif letter shapes

This effective design is similar in
character to the last one, and the
basic right-angle arrangement gives
it a firm yet effective simplicity

Other simple experimental image-making

Office stamps are a ready-made source for simple experimen-
tation. We all like to doodle in meetings or to play 'offices' with
office stationery, typewriters, labels and stamps. In these
illustrations two or three students have quickly produced
stamped designs, placing the images close together, far apart, or
on top of the images beneath. Although they are extremely
simple in nature it will readily be appreciated that such doodling
can, in fact, be serious design-making.

In this, far left, example I set out
the word 'narn' with black Letra-
sign letters and reversed this
beneath as a mirror image. How-
ever, an irregular shape resulted
from the reversal of the letter R

In an attempt to make the last
design a little more interesting I
developed the idea a little further
by introducing the letter P twice in
red. The result is not very success-
ful, however, and might have been
better if the spaces between the
black letters had been increased.
This would have given more con-
trast between figure and ground
while improving the design itself

This is another example where a large, red sans serif letter O forms a strong basis for the design. In this case the majority of the large black letters radiate out from the central letter, except for the letter R on the left-hand side of the design which is discordant with it, and the mass of tiny letters are framed in the centre to give a rich, if microscopic, pattern that is quite random in concept. It should be noted that both Letraset and Prestik letters were used

If you can obtain some old office stamps and ink-pads (red, black, purple, blue) you could produce a variety of experimental designs yourself.

Ideas
1 Use one stamp to make a series of parallel lines.
2 Do another design in which horizontal and vertical stampings inter-relate with each other.
3 Draw with a pencil around a tin lid or small plate and produce a circular design.
4 Why not use a stamp and coloured inks in conjunction with some *Letraset* or *Prestik* letter designs? This could change their characters and give you different effects.

An office typewriter, too, can be used inventively by even the most inexperienced operator. Alan Ridell's book *Typewriter Art* (London Magazine Editions) contains many interesting examples and I can recommend it as a source of ideas. These illustrations were done on my own rather ancient portable machine and a modern electric model. They show that it is possible to produce both abstract patterns and visual messages.

This illustration demonstrates clearly the possibility of cutting large Letrasign letters into quite different but very interesting geometric shapes so that the actual character of individual letters is lost. In this instance the cutting was done quickly with a pair of scissors although sometimes more care will be needed. Only two complete letters are to be seen in the design, an O and an R, with the remainder being almost totally abstract in essence. The visual effect of this design, although it will not appeal to everyone, has a pleasant appearance and I am convinced that the reader who tries out experimental ideas such as this will find this kind of work a stimulus to other forms of creativity.

An interesting pattern effect produced by sticking down the remains of some of the instant lettering sheets used in the previous illustrations. I particularly like its strong and lively effect

This illustration shows the design in one of the previous illustrations being used in a draft layout for one of the page-designs for this book with some text (cut out of an old magazine) related to it

51

Instant letters give this Christmas card a special and vigorous quality, while the reversal of the black/white to white/black figure-ground imagery adds considerably to its graphic qualities

UNIVERSITY OF BRISTOL
SCHOOL OF ART EDUCATION

MENTALLETTERINGEXPERIMENTALLETTERING
MENTALLETTERINGEXPERIMENTALLETTERING
MENTALLETTERINGEXPERIMENTALLETTERING
mentalletteringexperimentallettering
mentallettering experim entallettering
xperimental lettering experimentallett
rimentalle lttering exp crimentall
ngexper imental lettering experim
ental l letteringex p eriment aller
tal letterin gex p eriment alletter
rintgAl I lteringexp rimeng a ppetter
ringe xperi m entallett eringex
Rteilletter eingexperimen ngexpapetter
perim enatl letteri ngexperim entall
rlettering exp erim entalletta ringe
letterin gex inevinextallet EIRGEXP
LETTERINGEXPERIMENTALLETTERINGEXPER
lletteringexperimentalletteringexperi
itall letteringexperimen t LLLE t terih
mentalletteringexperimentallettering
mentalletteringexperimentallettering
mentalletteringexperimentallettering
mentalletteringexperimentallatterir

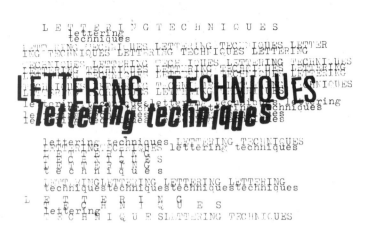

LETTERINGTECHNIQUES
lettering
techniques
LETTERING TECHNIQUES LETTERING TECHNIQUES LETTER
ING TECHNIQUES LETTERING TECHNIQUES LETTERING TECHNIQUES
LETTERING TECHNIQUES LETTERING TECHNIQUES LETTERING
LETTERING TECHNIQUES LETTERING TECHNIQUES LETTERING

LETTERING TECHNIQUES
lettering techniques

lettering techniques LETTERING TECHNIQUES
LETTERING TECHNIQUES lettering techniques
TECHNIQUES
techniques
LETTERINGLETTERING LETTERING LETTERING
techniquestechniquestechniquestechniques
LETTERINGS
TECHNIQUES
lettering
TECHNIQUESLETTERING TECHNIQUES

54

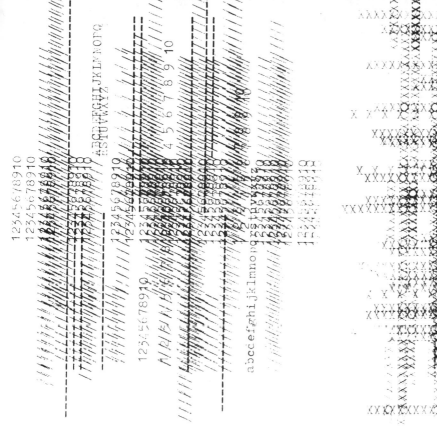

```
££££££££££££££££££££££££££££££££££££££££££
££££££££££££££££££££££££££££££££££££££££££
££££££££££££££$$$$££££££££££££££££££££££££
££££££££££££££$$$$££££££££££££££££££££££££
££££££££££££££$$$$££££££££££££££££££££££££
££££££££££££££$$$$££££££££££££££££££££££££
££££££££££££££$$$$££££££££££££££££££££££££
££££££££££££££$$$$££££££££££££££££££££££££
££££££££££££££$$$$$$$$$££££££££££££££££££££
££££££££££££££$$$$$$$$$$$££££££££££££££££££
££££££££££££££$$$$$$$$$$$$££££££££££££££££££
££££££££££££££$$$$$$$$$$$££££££££££££££££££
£££££££££££££££$$$$$$$$$$$$$$$$$$$$$$$$$$$$
£££££££££££££££$$$$$$$$$$$$$$$$$$$$$$$$$$$$
££££££££££££££££$$$$$$$$$$$$$$$$$$$$$$$$$$$
££££££££££££££££$$$$$$$$$$$$$$$$$$$$$$$$$$$$
```

Controlled developments

Lettering of all kinds depends for its effectiveness upon the use of strongly conceived, confidently made visual forms and good spacing. This illustration shows an arrangement of straight lines. It was done by an art student who was asked to design a very simple optical pattern using a piece of card, black ink and a basic printing technique. He worked quickly to produce the resulting mass of criss-crossing lines

The type of instant lettering which we have been considering can be reproduced by anyone, and it is obviously not enough simply to go on repeating it. My concern is to capture interest, not to stifle it, by expanding on simple tricks, for I believe that exciting beginnings can do more to get the average person started than any other method.

The illustrations in this section show that the designers, whether they were pupils, students or mature artists, took a great deal of care and effort. They certainly used their imagination to the full and coupled this with a high degree of skill.

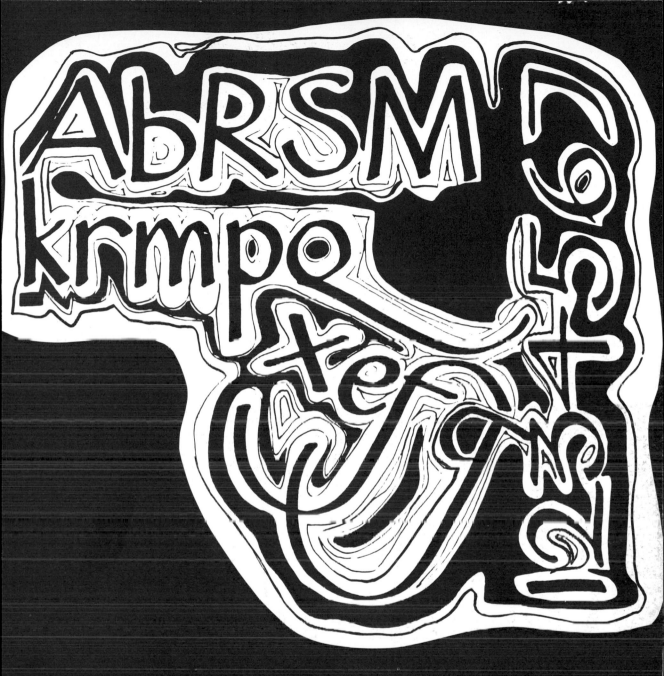

*The same student made this design
of script letters and numerals.
These were actually done with a
strip of card, ink and a ball-point
pen and the bold outline was added
later*

The word 'Cheltenham' has been used here as a basis for this pattern. Two loosely held felt-tipped pens were used and give it an effective quality. This is a good way of producing two-lined lettering

This panel of freely executed capital letters seems to combine naivety and sophistication to produce a pleasing overall effect. *Mabinogi Iesucrist* by David Jones. Reproduced by permission of the National Museum of Wales, Cardiff

Susan Eaton, a BA student at Exeter College of Art, exploited lettering in this portrait

58

59

Experimental lettering is not a new thing, as this early sixteenth-century example shows. The designer has used human figures and animals to form the letters. British School c 1520-30 — pattern book copied partly from German models (Dürer, the Grotesque alphabet of 1464 etc) Reproduced by kind permission of the Bodleian Library, Oxford (Ref: MS Ashmole 1504 fol. 45v)

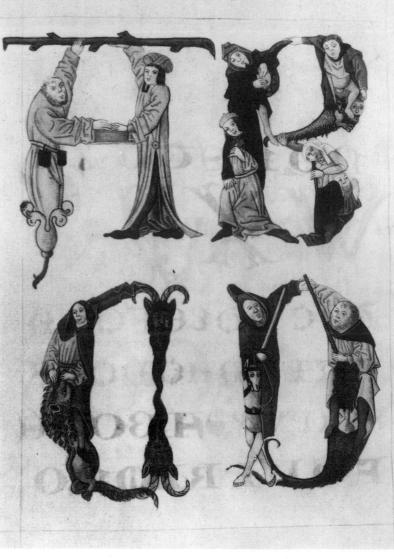

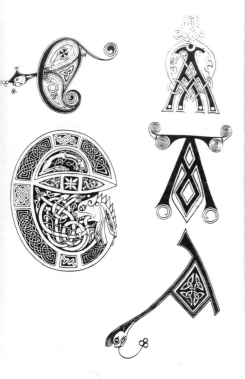

Interlacing strapwork and animal heads were an inventive feature in Celtic art. These decorative letters in the Book of Kells were copied by students who were making historical studies of the work of medieval scribes

This photograph of the Chi-Rho page, St Matthew's Gospel, is from the Book of Kells. It is one of the most beautiful and elaborately illuminated initial pages in this manuscript and I have included it here to show that Irish craftsmen in the seventh and eighth centuries excelled in their approach to experimentation resulting in beautiful works of art. This page is simply overflowing with interlacing Celtic ornament — strapwork, roundels, decorative heads, etc — but even so, the letters XPI are clearly in evidence
Reproduced by permission of the Board of Trinity College, Dublin (Ref: fol. 34r 'The Birth of Christ' Chi-Rho page, from St Matthew's Gospel)

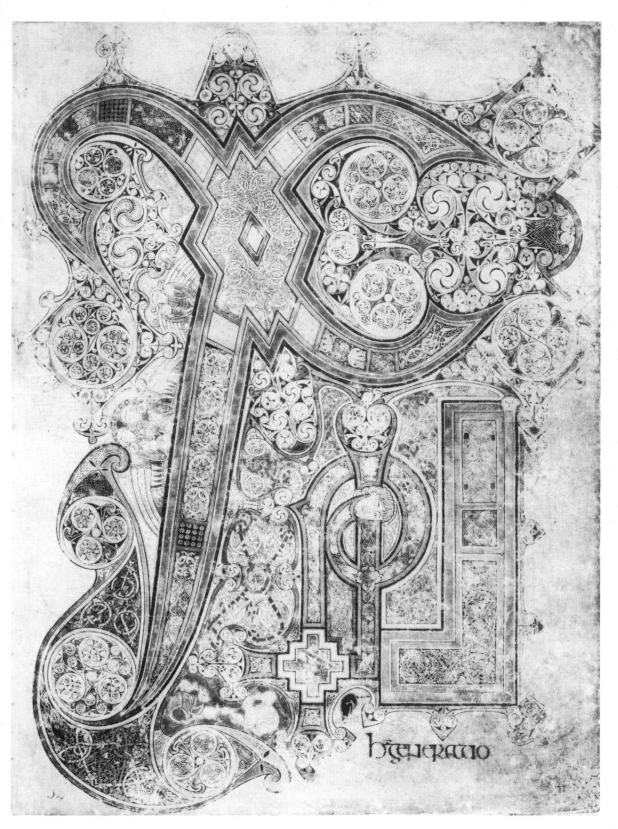

ħ generatio

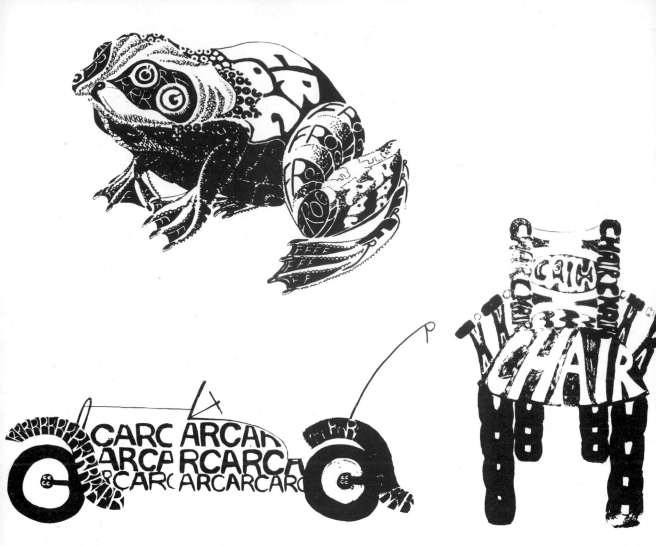

Examples by postgraduate students
showing letters depicting objects

An inventive drawing by a pupil at
Colston School in Bristol

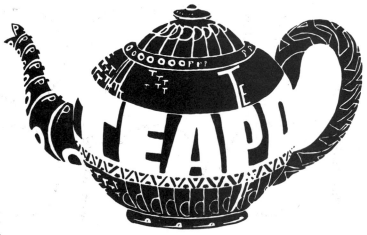

Basic letter forms

Every letter of the alphabet as we know it, is basically created from a circle, or part of a circle, and straight lines. Before going on to deal with pen letters, therefore, I suggest that you might like to practise making letters with circles and straight lines.

The simplest thing to do is to print these. For instance, you can take a bottle top or tin lid, ink it and print any number of circular images with it. A strip of wood or card — even an old matchbox — will enable you to print straight lines, and if the card is flexible you can then go on to flex it so that it gives you letter shapes such as C, G, S and U, or the curved parts of letters B, D, J, P, Q, R, etc. It is also good practice to arrange printed straight lines and curves together to obtain closely juxtaposed images, patterns or letters. This will help you to develop your skill in spacing and arranging lines of lettering — an invaluable asset at a later stage when you begin to design page-openings, illuminated addresses and notices. Some very simple, printed forms can be so arranged that they will look like rows of lettering on the page of a book.

Dot and stick letters
It is now relatively simple to move on to what are simple and easy-to-make dot and stick letters. I find a felt-tipped pen to be

This illustration shows how a lady who attended one of my evening classes used the end of a piece of wood to make some straight lines. She then took a circular tin lid for the letter O

one of the best instruments to use for this purpose, although ball-point pens, pencils, crayons and large brushes (for large work) may be invaluable. It is also a relatively simple matter to print letters such as these with sticks, strips of card or wood and the rounded ends of pencils.

I feel I need not explain to you how to do this kind of lettering for the illustrations show their basic characteristics. Just copy the next few images and then invent some of your own while developing further ideas.

An interesting arrangement of lines, stamped quickly by a student with a potato block, as a 'spacing' exercise

An exercise in which straight lines emulate lines of lettering so that the student will gain in confidence

Line and dot lettering produced with a ball-point pen

Bold letters printed from card and wood

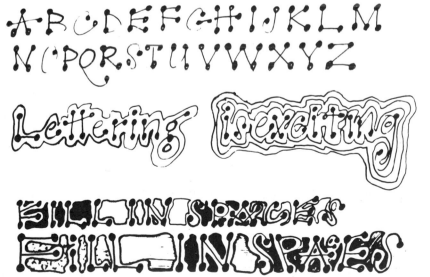

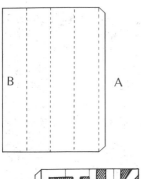

An idea for a standing structure

If you follow a simple procedure it is relatively easy to design and make a small piece of sculpture in the form of a standing structure. You will require some firm card (you determine the size and colour), as shown in the diagram with tab *A* scored lightly and folded along the dotted line so that it can, at the final stage, be glued under *B*. Bold sans-serif letters or numerals are drawn onto the reverse side of the card, the 'right' or 'wrong' way round, and the negative areas between the images (shaded areas in diagram) are cut away with a sharp knife or razor-blade. The letters must be allowed to touch (top, bottom and sides) to give the structure sufficient strength to stand unaided, as shown in the accompanying illustrations.

Variations and developments

1 Metal sheeting (copper, brass or tin) could be substituted for the card to give you a much more durable and stronger piece of sculpture. The inside surface could be sprayed with a brightly coloured gloss paint to contrast well with the highly polished exterior surface.

2 One of your card constructions could be more effective if each of the exterior sides were painted a different colour.

3 Three or four structures of varying size and colour could be attached to a polished wooden base so that they related to each other. They might even be stuck together to add structural strength.

Standing structures by ATD students at the University of Bristol School of Education, who used scrap pieces of card. They were allowed only 40 minutes for this creative work

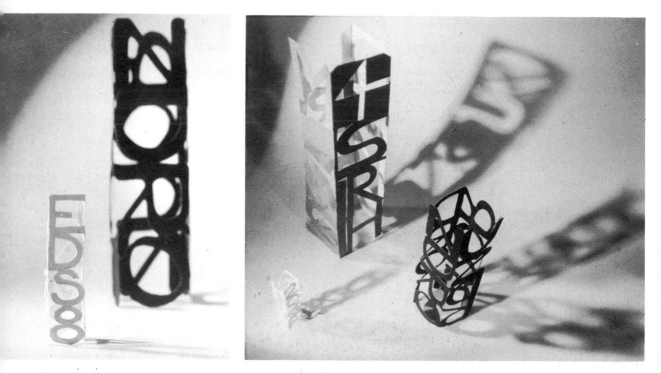

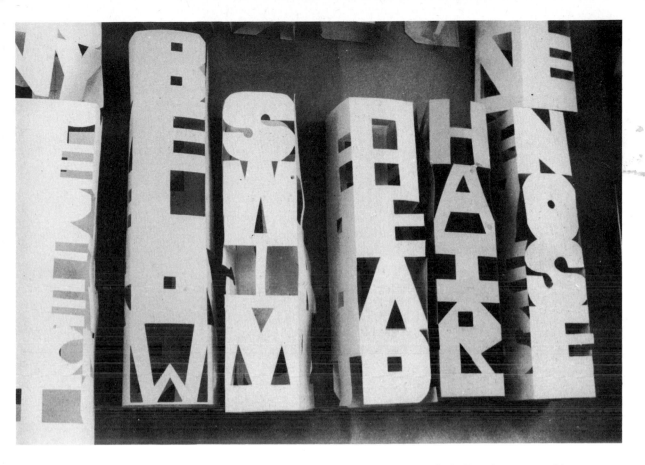

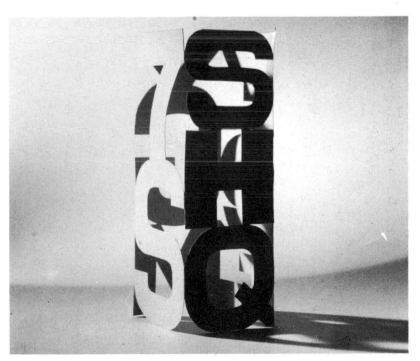

A similar idea was used by comprehensive school pupils at Frome College in this relief panel

In a series of 'line' experiments this student made a standing structure out of card letters

67

Calligraphy:

Making a simple start with pen lettering

Calligraphy is 'handwriting as an art'. To some, calligraphy will mean formal penmanship. It will suggest manuscript books, broadsides and scrolls, with precise scripts against which are set the vivid colours of illuminating and the glitter of burnished gold. Others may think of calligraphy as the cursive handwriting used for correspondence and records which has legibility and beauty in spite of a swift pen. Calligraphy, then, may be considered as covering formal and informal handwriting, and to be found in the enduring and precious manuscript book preserved on the book-collector's shelf or on the envelope already lying in the waste-paper basket.

Formal penmanship will be appropriate for the work of art. It indicates the best materials and tools and methods, with time to employ them worthily, and occasion or purpose to require the thing to be of special value or interest. Cursive handwriting is a modest and expedient penmanship, but, if humble, not essentially humdrum. Its simpler character does not imply that it is stripped of fine form. (Note 2)

As I noted earlier, when I was an art student I specialised in writing, lettering and illuminating, a delightful aspect of the visual arts whose roots are firmly entrenched in the history of the human race. My tutor, Thomas Swindlehurst, taught lettering in quite a formal manner on this two-year course (Note 3), basing his methods on those of his own student days at the Royal College of Art.

The first instruction I received from him was to acquire a half-imperial drawing board, a ruler, pencils, paper (a varied selection of cartridge and hot-pressed hand-made paper for better work), a set of William Mitchell's square-ended nibs (numbers 6 to double 0); a number of pen-holders; tiny brass reservoirs (which slid beneath the nibs to hold a reasonable quantity of ink); a putty rubber; a range of water colours and fine, levigated powder colours (particularly orange, vermilion, yellow, blue, green and white to add body); some books of gold leaf and transfer gold; a jar of raising preparation; some gold size; sable brushes of the best quality and in various sizes; two agate burnishers and some non-waterproof black Chinese stick ink. Later this basic kit was extended to include a selection of quills (turkey, goose and crow feathers); a scalpel (penknife) with which to cut them; some shell gold and pieces of fine manuscript vellum (calfskin, goatskin and sheepskin) and

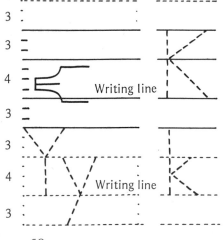

materials for pouncing it.

When my fellow students and I were ready to start our pen-lettering 'Tommy' wrote a modified tenth-century Winchester script on the blackboard with a piece of square-ended chalk. This included capital and lower-case alphabets, with the proportions of the letters pragmatically determined according to the width of the writing instrument: ie seven pen widths = height of the capitals, with the lower-case letters = four pen widths and descenders and ascenders = three. The diagram illustrates this principle.

Serifs and flourishes were neatly done and their construction carefully explained. We had to copy and copy and copy until perfection resulted; a frustrating and long-winded affair. Our boards had to be at an angle of approximately 45° to the horizontal. (I prefer to be more flexible and suggest that the writing surface should slope at a comfortable angle.)

Many of my own pitiful attempts at calligraphy resulted in smudged and blotted pages and my expertise with pen and ink was slow and agonisingly painful to acquire. My tutor did not make any attempt to encourage experimentation and inventiveness, rather, his maxim was that a beautiful writing hand — the Winchester script in this case — could only result from pure and direct copy of it with traditional writing implements and materials exactly as the scribes had been expected to do in the scriptoria attached to the monasteries in medieval times. (Note 4). I did not question this approach and reiterate that when I began to teach pen lettering I did likewise. I too wrote on a blackboard and insisted on the transcribing of 'my' version of tenth- and twelfth-century scripts with square-ended pens and black ink.

Experimenting

As I became more experienced I decided to experiment in my teaching and encouraged my students to be a little more adventurous. The result is that I now have no set way of teaching calligraphy and vary my approach to suit my mood and interests and, indeed, the moods and interests of the students in my classes. My main concern is to consider that lettering is simply a means of visual communication and that in producing it we should have a lot of fun and try to enjoy ourselves immensely. I still use chalk and a blackboard or, better still, a piece of felt dipped into ink with which I write on a large sheet of paper, but I also experiment as I teach.

For instance, a blackboard which has had chalk quickly scribbled over it (any available colour does quite nicely) is then ready for the production of calligraphic forms which I find I can make easily with a piece of felt, about 25 mm (1 in.) wide, dipped in water. This results in crisp, black marks which are instantly effective, although it must be appreciated that the water dribbles and the marks tend to fade fairly quickly. The

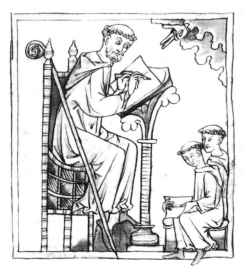

An illustration of a scribe writing. Thirteenth-century English manuscript
Reproduced by courtesy of the Bodleian Library, Oxford *(Ref: MS Laud Misc 385 fol. 41ᵛ Flores Bernardi)*

unexpectedness of this technique stimulates an immediate interest and I find that students can't wait to have a go themselves. They too can experiment on a blackboard in a similar way, also using square-ended pieces of felt or the cloth-covered ends of rulers or pieces of card dipped in water. As an alternative to a blackboard they often cover pieces of black paper or card with chalk and then experiment. Their inhibitions quickly evaporate and their initial attempts are often quite astonishing in their confident directness. The aim of such an approach is to give students the feeling of instant success so that they develop confidence and rapidly achieved expertise. I would suggest that even the experienced calligrapher might benefit from an occasional divergence into such experiences.

The two ball-point pen approach
A couple of ball-point or felt-tipped pens can also be used most successfully as a writing instrument. It is a simple matter to bind two pens together with rubber bands or sellotape and the distance between their writing points can be varied by inserting small pieces of card between them before the fastenings are finalised. I often use this technique for quickly written notices and have become quite skilled at holding two pens without the need to bind them together at all. I can now produce either bold, large letters, or tiny ones, according to my desire. What is required is practice and a spontaneous approach. Once again the main value of such a method is to give the aspiring calligrapher instant success for he is able to produce letter-shapes quickly and naturally. There is, after all, no ink to blot; neither does he need to worry about pens which won't work properly, reservoirs which drop into an ink bottle, or black ink which sometimes tends to smear all over his fingers and the writing surface itself.

To introduce students at the University of Britstol to a different approach, this experimental lettering was written with two ball-point pens, one blue and the other red and this demonstrates the lively effect which is possible from such a simple technique. This is really a calligraphic drawing, full of freedom and vitality, and it can lead the potential scribe to go on to use a pen with some conviction and a great deal of confidence

In this instance, the capital letters were produced by holding two black felt-tipped pens in the writing hand, while the lower-case alphabet resulted from a combination of a pencil and a ball-point pen. The scribbled-in areas give extra vitality and were done very quickly with one of the black felt-tipped pens and a pencil. It is worthwhile to try out a simple method such as this for the ink marks dry extremely rapidly, without smudging and felt-tipped pens are easy to use. This example was done to demonstrate to students the possibility of producing similar images with the main emphasis on excitement and instantaneous effects

Practical ideas

Hold your two-point writing instrument as you would a square-ended pen (see page 81) and you should find it relatively simple to use. You should experiment freely by varying the writing angle so that the calligraphic images produced differ in style. It you are unsure, however, it might be helpful to work through the following ideas:

1 To begin with make a series of vertical lines with your two-point pen. Do these along three horizontal rows: row one 51 mm (2 in.) high; row two 102 mm (4 in.) high; row three 153 mm (6 in.) high.
2 Repeat this basic exercise but this time use curved forms or circles.
3 Go on now to combine straight and curved forms so that you end up with interesting rows of patterns.
4 Produce some rows of V-shaped patterns.
5 If you colour in some of the patterns with coloured felt-tipped pens or even water colour paints your designs will become more individual and visually exciting.

Two ball-point pens — one red and the other black and textural effects make this rather mundane notice a little more attractive to the eye. It was produced very quickly, in about three minutes, which demonstrates the value of this technique

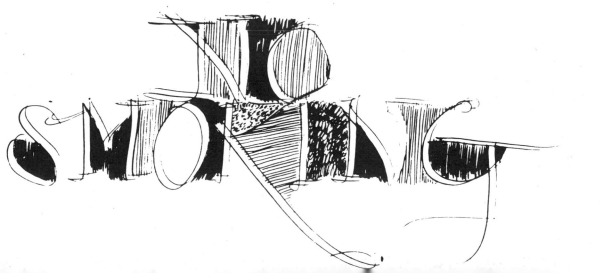

Such simple beginnings as these will help you gain a mastery of your two-point pens before you go on to the making of actual letters. You will require a few sheets of good drawing paper of course, although old wrapping paper can be an invaluable and cheap substitute, and felt-tipped pens will give you strong, firm images.

More ideas

1 Draw a grid with pencil, ball-point or felt-tipped pen within a 381 mm (15 in.) square (see the illustration), spacing the *vertical* lines at 76 mm (3 in.) intervals. Vary the spaces between the *horizontal* guide lines, however, making these intervals 51 mm (2 in.), 127 mm (5 in.) and 203 mm (8 in.); *or* 102 mm (4 in.), 203 mm (8 in.) and 76 mm (3 in.); *or* 178 mm (7 in.), 76 mm (3 in.) and 127 mm (5 in.), etc so that the letter-shapes you produce will differ in their heights and proportions (see the illustrations A, B). Now select five or six letters from the alphabet which are comprised solely of straight lines and draw these (in any order) on the horizontal guidelines with your two-pointed ball-point or felt-tipped writing instrument. This should give you an interesting letter-pattern which you might wish to complete by filling in some of the negative spaces both within and between the letter-shapes with flat areas of tone, colour and small textures.

2 Repeat the suggestion above but this time draw your grid within the framework of a larger square or rectangle. Change the distances between both the horizontal and vertical guide-lines (see illustration C).

 This time I suggest that you select a small number of letters composed of straight and curved lines. Draw these within the grid, turning it around so that the letters are formed the right way up, sideways on and upside down. Allow some of the letters to touch other letters and/or the edges of the square. Complete your design with colours and textures.

3 Now go on and develop your own variations on these ideas. Why not use a circle in which to draw your grid of squares or rectangles? Employ horizontal waves instead of straight lines as a basis for the construction of the letters. Consider vertical stripes.

 Complete with collage materials or paint instead of felt-tipped colours, or combine a variety of materials.

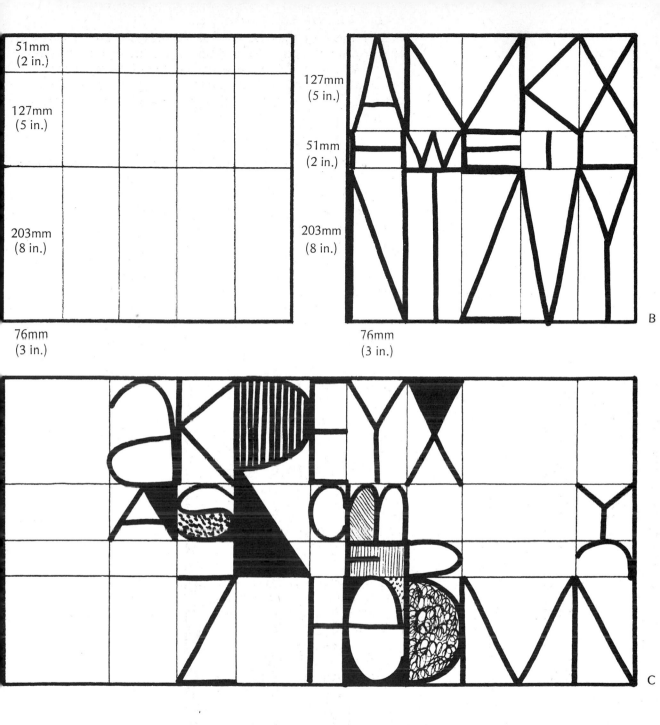

51mm
(2 in.)

127mm
(5 in.)

203mm
(8 in.)

76mm
(3 in.)

127mm
(5 in.)

51mm
(2 in.)

203mm
(8 in.)

76mm
(3 in.)

B

C

73

Calligraphic images

Occasionally it is wise to forget all about lettering and to concentrate simply on producing 'calligraphic' images. Some of these could be quite tiny (twice the size of a postage stamp) and done with the end of a pin, a needle, a crow's quill or a small sable brush whilst, in contrast, others could be large 'action' paintings produced by such implements as sticks, household painting brushes, pieces of rag or even decorator's rollers on large sheets of brown wrapping paper or board. Calligraphic marks such as these do not rely for their effect upon formal structure, as letters do, and can be enjoyed simply as juxtaposed graphic images.

I find this kind of work tremendously exciting and it has helped me to be much more dextrous with pen and ink and my lettering with two ball-point pens. Even monoprinting — a printmaking technique in which ink is spread evenly over a flat surface (ie a sheet of glass, formica or plastic) before calligraphic marks are drawn upon it and from which a monoprint is pulled — is a stimulus. It produces imagery relying upon directness of technique, but also includes accidental and often quite charming subtleties of tone and texture. (Note 5)

Practical ideas
For each of the following prints you will, first of all, need to spread (with a brush or roller) a thin layer of water-based printing ink on to a small inking-up slab of glass, formica, hardboard or card (card with a shiny surface is useful for this purpose, ie an old cereal or soap powder packet). Your inking-up slab can be quite small in size (ie 152 mm x 152 mm (6 in. x 6 in.), 102 mm x 203 mm (4 in. x 8 in.), etc) but it might be sensible to place it on a larger sheet of newspaper before you start so that you won't make a mess of your work table.

Having inked-up the slab you can now lift off some of the ink with your fingers, a piece of stick, card, tin, bone or the end of an old ruler. You then lay a sheet of clean paper onto the inked surface and press it down firmly but gently. Now carefully peel it off and you have a monoprint.

Make the following prints:
1 thin vertical lines
2 criss-crossing lines

74

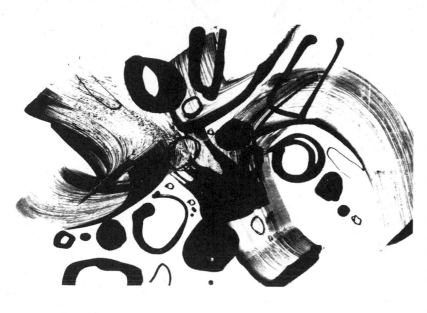

Lettering depends fundamentally upon confident mark-making and this illustration of what is really only a simple pattern results to some extent from my attempts at abstract painting. The calligraphic forms are quite large and were done with a 152 mm (6 in.) household painting brush and a stick on a hardboard panel, with black acrylic paint. Occasionally I find it is useful to work on a large scale with brushes, or paint-soaked pieces of rag, on large sheets of brown wrapping paper, hardboard or even prepared canvas. This method seems to get rid of all my inhibitions and gives me a confidence which I tend to retain when I return to pure penmanship

3 thick and thin lines
4 wavy lines
5 freely executed 'calligraphic' squiggles
6 bold letters (A E I O U). These should be done with a strip of card (approximately 13 mm (½ in.) wide), *the wrong way round* so that they print correctly.
7 two-point letters done with two pointed sticks joined together with rubber bands
8 dot and stick numerals
9 large and small — a combination of various letters and numbers
10 a monoprinted notice reading Good Lettering Is Easy To Read
Develop these and other ideas of your own by experimenting quickly.

Mark-making with card and stick

The use of modern implements and materials is a boost to the artistic morale and, as the examples show, the development of personal writing styles in this way is quick and positive. A great deal of practice results and this leads on quite rapidly to the next stage which, as far as I am concerned, is the use of card or pieces of stick.

Match-boxes or old cardboard boxes can be cut up to provide materials for use in basic mark-making. All we need is a pair of scissors with which to cut the card into strips to the widths required, although it must be remembered that the wider a strip the larger will be the resulting letters. We can then cut each strip of card across the end, dip it into ink (ordinary fountain pen ink and any colour will do very well) and experiment with it. A square end will give a different character of letter from that

produced by an obliquely cut piece of card, and although the card will become soggy after a relatively short period of use it is so cheap and easy to obtain that this is a minor problem. A more substantial material than card is obviously wood, and strips of balsa wood can be used quite effectively.

Rapid pen techniques
I get a tremendous thrill when I virtually attack a piece of paper with a pen, and find that the freely written lettering this produces is ideal for quick posters or notices. In my earlier years as a teacher in schools and colleges I would spend a lot of time producing a work of art, almost as a formal illuminated address, for all kinds of notices, only to have these torn down after a day or two. Experience soon taught me that speed was essential and that the exciting effects of rapid lettering could often be much more advantageous than very carefully produced work.

So, speed, excitement, vigour, fun, soon caught hold of my penmanship. This included the inevitable blots and smudges, a rather off-putting factor to the purist but this did not bother me much and I developed what I feel is an effective approach to the business of rapid communication. This soon produced demands from pupils and students to teach them how to do it: demands which pursue me constantly to this day. And, of course, it is much quicker and easier to teach and master than formal scripts.

A pianist will juxtapose five-finger exercises with his serious music making. The calligrapher, too, will practise before sitting down to do his best work. I find that if I cover a large sheet of formica or the smooth side of a piece of hardboard with water-based printing ink, using a roller to spread this medium evenly, I can then draw with my fingers or other suitable mark-making implements in a direct calligraphic fashion. This mono-print of calligraphic forms was done in this way by a young student before he went on to try out more difficult-to-control pen and ink work.

Pen patterns

I suggest that you should experiment freely to see how bold your lettering can be and which materials give you the most satisfaction and the best results. Try to inject what you do with as lively a vitality as possible. Be inventive but careful. It is wise for the beginner to ignore letter-shapes at first for these are quite complicated forms requiring a mastery of pen techniques. If you are about to start, therefore, I would suggest that you should concentrate, like the young child who is learning to play the pianoforte, on doing very basic 'five-finger exercises'.

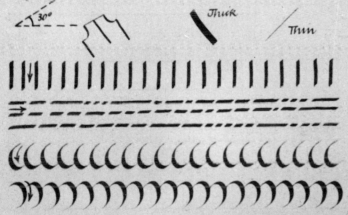

This page of pen patterns, one of many which I have produced for my lettering classes, was written in just a few minutes and then photocopied so that each student could have a copy. It is self-explanatory

Demonstration lettering done by Thomas Swindlehurst when teaching calligraphy at Leeds College of Art in 1949

Simply practise making patterns with the pen. This will promote confidence, control and speed of execution.

Practical ideas

Take a number 2 nib, a good size of pen which will enable you to make bold, clear images, and begin your pattern-making. Hold the pen naturally so that it forms an angle with the horizontal writing line of approximately 30°, but I would suggest that you do not worry about this; just let the shaft of the pen point over your right shoulder (that is if you are right-handed) with your elbow tucked loosely into your ribs. After taking note of this general rule be natural and, above all, be comfortable. The marks you make should be *thin* (upwards) and *thick* (downwards towards the right). Now simply copy the pen patterns shown until you are satisfied that you can do this reasonably well, and then invent some new ones of your own. Practice results in perfection and so the more you write with your pens the more skilled you will become.

More formal pen lettering

When I teach more formal aspects of script I tend to turn to the forms of Carolingian minuscule advocated by Edward Johnston, which can be dated approximately between the ninth and thirteenth centuries, concentrating mainly on a Winchester hand. Anderson refers to a Psalter, Harley Manuscript 2904 in the British Museum, in which the development of a stronger pen stroke than earlier is in evidence, being based on Carolingian models. He writes:

> Aesthetically the writing is important because the ascenders and descenders have been brought into harmony with the main body of the minuscules. Early versions of Roman minuscule (half-uncial) demonstrated that the script had two origins, uncial and popular cursive, and it had always bothered aestheticians of the letters that the stylistic unity of the early uncial writing was not approached again during the times we have covered. Roman cursive traced its own course, created its own spatial environment and reason for being; but its intrusion into the geometric unity of early uncials has disturbed many students of writing. In Harley 2904 we see that the two styles of antiquity have been successfully blended. (Note 6)

Indeed, Anderson stresses that the writing in this manuscript is '. . . a good piece of calligraphy — one of the rare times when a penman creates a statement for posterity. . . .' and is similar stylistically to twelfth-century examples from Italy. It is characterised by short ascenders and descenders, with '. . . a harmonious flow of round and vertical shapes with impeccable spacing of letters. . . .', and was a powerful influence upon Johnston who stated that '. . . it has all the qualities of good writing in a marked degree, and I consider it, taken all round, the most perfect and satisfactory penmanship which I have see.' It obviously became Johnston's model.

In my teaching I now rely quite heavily upon the photocopier, a machine which saves endless time and energy. Quickly written examples of experimental and formal lettering can be copied easily so that every student can have his own to take away and use, unlike those written on a blackboard, which tend to be wiped off much too soon by over-enthusiastic board cleaners after a session has ended. It means that the aspiring scribe is able to practise with his letter-samplers very close to or

Lower Case Letters

a	ꞇ a a	b	ꞁb
c	e c c c	d	c ꞇ d d
e	ꞁe	f	ꞁ ꞁ f
g	ꞁ g g g	h	ꞁ ꞁh
i	ꞁ ꞁ ꞁ	j	ꞁ
k	ꞁ ꞁꞁ k	l	ꞁ
m	ꞁꞁꞁ m	n	ꞁ ꞁo o
p	ꞁꞁ ꞁꞁ ꞁꞁ p		ꞁꞁ Q
s	ꞁ s s s	r	ꞁ ꞁ ꞁ
u	ꞁꞁ ꞁ u	t	ꞁ ꞁ t
w	ꞁ ꞁ ꞁ ꞁ w	v	ꞁ ꞁ ꞁ v
y	ꞁ ꞁ y y	x	ꞁ ꞁ ꞁ x
		z	ꞁ ꞁ ꞁ Z

This rather well-used sampler of lower-case lettering, once again photocopied and given to students, was an invaluable teaching aid. The pen strokes were numbered, with the directions of individual strokes indicated by small arrows, so that the students should have simple instructions to follow

I produced this teaching aid some years ago when I was teaching secondary pupils. The reproduction costs were minimized by having it printed in the school magazine

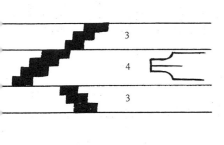

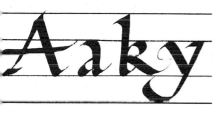

actually on his writing surface next to his own efforts. He learns the mechanical skills much quicker for he does not need to lift his head, re-focus from close work to long-distance viewing, and then attempt to register often pale chalk lettering on a blackboard some distance away from him. If you think about it this is a difficult operation. I even suggest to some students that they might place a sheet of thin typing paper on top of their photocopied sampler and then use a tracing method. It might not be a purist's approach but it sometimes works well and stimulates confidence and further interest.

The basics of a formal script

1 A square-ended pen is essential.
2 The pen should be held in the right hand, pointing over the right shoulder and its square writing edge forming an angle of approximately 30° to the horizontal writing line.
3 The fundamental character of this particular style depends upon firmly made straight and open, rounded forms.
4 The actual size of each letter is related to the width of the pen itself and although it can vary according to the demands of a particular piece of work, a useful guide is (a) the height of the capital letters and lower-case ascenders seven pen widths, (b) the small letters four widths and (c) the descenders three pen widths. These widths are calculated with the pen turned sideways (see illustration).
5 Copy the illustration of sample lower-case letters (page 80), in which the sequence of pen strokes making up each letter is given, until you acquire enough skill to enable you to write each letter independently.

*Preliminary page designs in which I
have juxtaposed freely written
script with sample text*

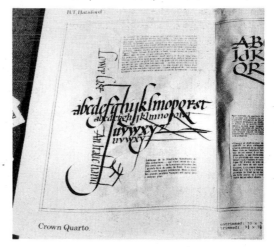

6 Proceed now to the capital letters and practise these carefully as you master the construction of each one. The sample will aid you and although I have not included the specific stroke sequence, as in the case of the lower-case example, you should find it relatively easy to determine this yourself.

7 Experiment now with individual letters, alphabets and numerals shown in the 'variations' and the 'decorative lettering' illustrations below.

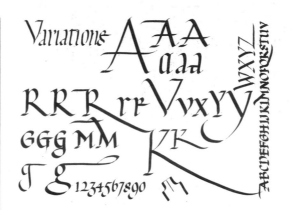

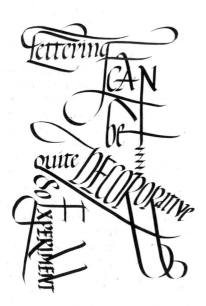

In addition the reader should find the following books of help: *The Young Calligrapher* by William Cartner (Kaye and Ward), a simply conceived and well written book which is concerned with basic pen practice. The author deals with equipment, the cutting of quills, ruling-up and spacing. He demonstrates the construction of both capital and lower-case scripts, including italic, and also shows how a manuscript book can be designed. This book is particularly useful for the beginner.

Writing, Lettering and Illuminating by Edward Johnston (Pitman). This has been a standard work for some years now. It is difficult to read as a book and should be used as an information source. Chapters 2, 3 and 4 will be of special interest for in them Johnston gives clear instructions on the use of pens and the formation of pen hands.

Calligraphic Lettering with Wide Pen and Brush by Ralph Douglass (Pitman). I have employed this book more than any other in my teaching. Each page is a reproduction of handwritten text, amply illustrated with line drawings and photographs. I like it best of all because it has a simplicity which is attractive to the pupil. It is instructive, educative and an indispensable resource for the person learning to write.

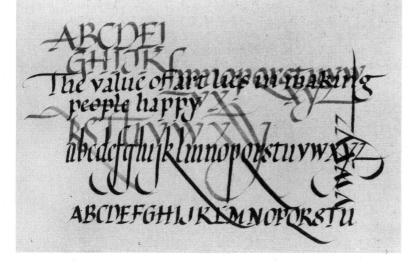

Double script

Double script lettering (double-lined pen forms) can be extremely effective and some modern calligraphers use it for decorative titles in books or to emphasise certain parts of rolls of honour or scrolls. Edward Johnston set the pattern some years ago and has been an inspiration to subsequent generations of penmen.

When double-script is used in formal work it needs to be precisely penned, with the two lines running parallel to each other, for if this is not done carefully and the supposedly parallel lines fluctuate, the effect may be ruinous. Indeed, careless work will look clumsy or even amateurish. If, however, the aspiring calligrapher who wishes to try this form of lettering is prepared to struggle and practise, then he will find it ideal for use as coloured, decorative initials or blocks of lettering which will contrast in an interesting and lively way with the main body of text.

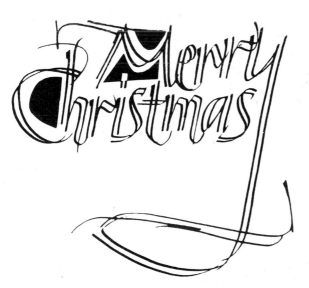

This example of double-script lettering is by David Howells whose very vigorous and freely written calligraphy seems to suit this style well. It shows him to be a master in its use, for he has absolutely no fear of the technique involved and the letters radiate his confident excitement and apparent pleasure in producing visual imagery. Howells uses his pens to produce bold, precise letters with a supreme knowledge of his craft, and it is apparent that he works with natural ease. The way he has penned the words Merry Christmas radiates a sense of fun indicative of the happy, festive season. This, for me, is what lettering is all about. It is a form of visual communication by means of which the designer/craftsman conveys ideas and human feelings

I find that if I produce the left-hand stroke first, then the right-hand stroke is relatively easy to do. A firm commitment is essential, however, for if I dither at all the odds are that the second stroke will waver and the parallel line effect will be lost.

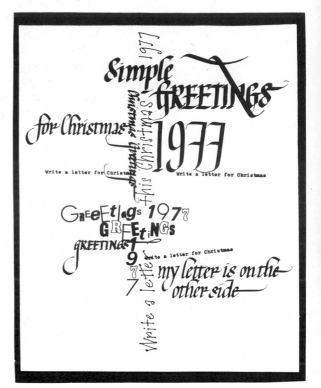

This design depends for its effectiveness upon the relationship of various letter-styles. These include both formal and informal pen letters, typed forms and Letraset *in horizontal bands, with a discordant effect produced by the single, vertical line of typescript*

141

I wrote this letter-sampler very quickly to demonstrate to a class of students how a square-ended pen can be used effectively. The lines of capital letters touch each other and the areas of ink, both inside and between some of the letters, were added with the back of the pen to show how this technique could be used

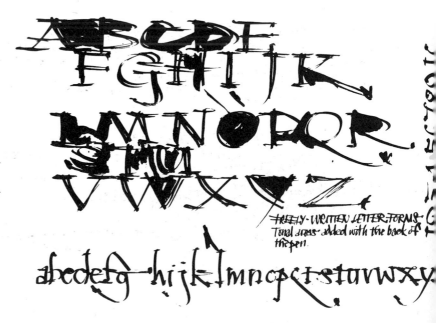

84

Developments

Once the rudiments of calligraphy have been acquired they provide the necessary techniques enabling us to develop the craft further. Greetings cards are an obvious beginning and this example demonstrates a simple possibility. The design was conceived and executed quickly with the hope that it would capture a feeling of vitality.

I have tried to evoke a sense of vigorous adventure in the next series of examples, turning the pen so that, as we have noted previously in rustic letters, the character of the script is changed, and I have allowed letters to touch each other and even used the back of the pen to fill in areas of solid ink. In my view it is extremely beneficial to work in such a way for it is apparent that the lettering produced radiates the confidence of the craftsman. It is then possible to write out menus and notices with speed so they do not look stilted or laboured. Even poetry can, as these student examples show, be less inhibited than normal college work.

Naturally it is important to develop new skills and techniques and I introduce students to the use of ink, egg-tempera and gold on hand-made papers and vellums. But I also encourage more unusual developments such as large-scale work in paint on large canvases, alongside other studio commitments and according to personal desires. Even studies of an historical kind play their part and examples from medieval manuscripts can be an invaluable inspiration.

Much more formal design is also possible and, indeed, formality is often essential when the occasion demands it. Thomas Barnard's example is a combination of inventiveness and formality and he has used his calligraphy with superb confidence.

A simple design (opposite) produced for my own use and to replace the usual Christmas cards, in 1977, which I reproduced on a photocopying machine. The idea was that I would write a personal greeting or letter on the reverse side. Note the use of formal script, dot and stick, typing and Letraset *letters.*

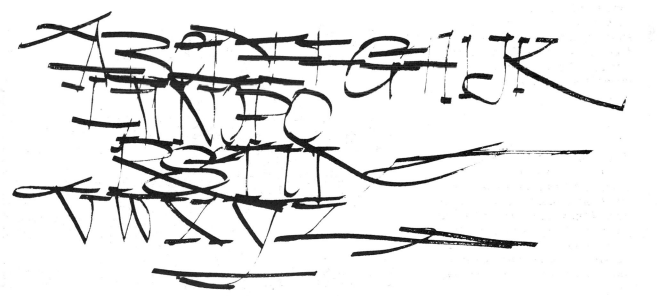

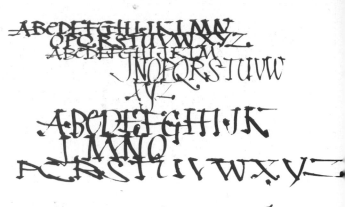

Top — another example of capital letters used freely to demonstrate how a pen which has been turned to a horizontal angle can be used
Bottom — quickly executed pen lettering for a simple notice

Fredy written alphabets · [pen angle = ΓΤ٦]

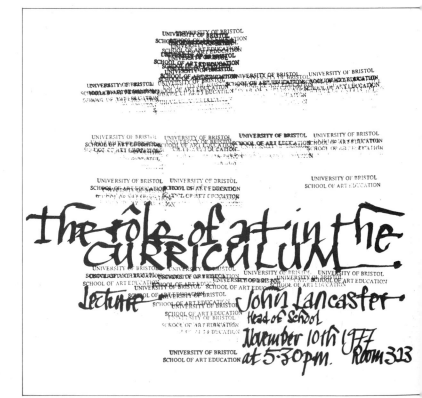

A rubber stamp and calligraphy were combined here and the result is quite an effective notice

86

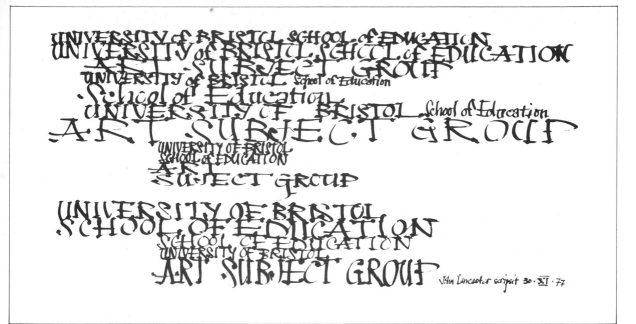

UNIVERSITY OF BRISTOL SCHOOL OF EDUCATION
ART SUBJECT GROUP

John Lancaster scripsit 30 · XI · 77

This lettering pattern was the result of pure enjoyment with a script pen. There are further examples on the following pages

Jubilee
PRO-AM GOLF
Tournament

CLEEVE HILL GOLF CLUB	16th August
LILLEY BROOK GOLF CLUB	17th August
COTSWOLD HILLS (illegible)	18th August

Celebrities include

Jimmy Hill Ed Stewart

Bobby Charlton

Billy Wright

Admission · FREE

Promoted by Pro-Line Golf Promotions

Printed poster

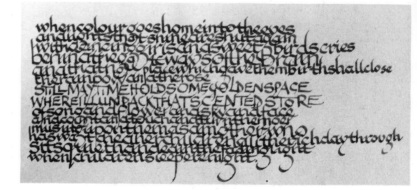

This lettering was done as an exercise in pure pattern-making. The page should be turned upside-down, then sideways, so that you can ascertain to what extent the student has been successful in achieving a consistent balance between the positive and negative elements

This is an example of a nicely written piece of work by a student who has obviously developed a confident approach in her manipulation of graphic, pen-made images. The writing has an overall and even consistency reminiscent of medieval manuscripts

It is often thought that calligraphy should result from using a small pen and ink. Here, however, we see a photograph of a large painting in oils by one of my students. He applied the paint with rags, sticks and brushes — following a basic introduction to both formal and informal script techniques — and is to be complimented on his bold adaptation of calligraphic imagery in what has become a lively abstract work of art

An abstract design in gold, red and green water colour, by a student who was inspired by letter shapes

I have included this fragment of written vellum here because it seems to fit in so well with some of the modern examples of experimental, freely written work. It was found in Cairo and the lower Latin script is uncial with the upper script in Hebrew. Sixth-century palimpsest. Reproduced by permission of Cambridge University Library *(Ref: CLA II 136 uncial Add. MS. 43200)*

89

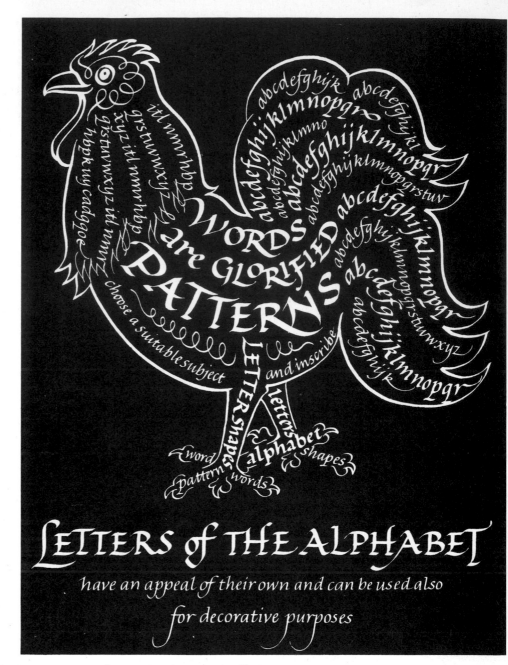

Designed and written by Thomas
Barnard. Reproduced by permission
of the Platignum Pen Company

Examples of modern calligraphy

There are numerous craftsmen working in the field of writing and illuminating today and so I shall limit my selection. The Society of Scribes and Illuminators is a most worthwhile and representative one which is helping to keep this aspect of the visual arts alive and its membership includes many well-known scribes and lay members. In this next section, however, I shall make a brief reference to only one calligrapher, a personal friend of mine whose work I admire, and follow it with some examples of Loyal Addresses presented to Her Majesty Queen Elizabeth II.

A Yorkshire Calligrapher

E John Milton Smith lives near Leeds, Yorkshire, and works — in his spare time — in a small studio at home. He was born at Stonehouse in Gloucestershire where his formative years were spent within a craft-orientated environment, his father being a master craftsman whose work was strongly influenced by the art and craft movement which flourished in the Cotswolds during the early years of the twentieth century.

With encouragement from his parents and teachers, upon leaving school, he attended the Stroud and Gloucester Schools of Art during the late 'thirties but in common with many students of his generation he found that his studies were to be interrupted by the Second World War. De-mobilised in 1946 he resumed his studies at the Leeds College of Art, where he specialised in writing, lettering, illumination and letter-cutting under the tutorship of the late Thomas W Swindlehurst.

In 1952, following the sucessful completion of his studies for the Art Teachers' Diploma, he became Head of the Art Department at Jones West Monmouth School, Pontypool, where, during the next decade he established a considerable reputation as an art teacher through the outstanding work of his senior pupils. Appointed to the staff of the Department of Art Education at the Leeds College of Art, in January 1963, he has since been concerned with the training of specialist art teachers, organizing in-service courses for teachers of art and crafts and working as an examiner for various college courses. He is currently Subject Leader (Art) in the PGCE Course within the School of Education of Leeds Polytechnic.

...gnation of the eminent service rendered by him...
...e former North Riding County Council as a County...
...ouncillor from 1949 to 1962 and a County Alderman from...
1962 to 1974 and to the North Yorkshire County Council
from 1975 to 1977...

92

Throughout his teaching career John Milton Smith has continued to practise his craft, thereby steadily increasing his mastery over the chisel-edged pen and maintaining his longstanding interest in calligraphy. While this has been largely for his own satisfaction he has occasionally carried out work for various civic authorities and private patrons. He has found, however, that the role of a teacher-trainer is a very full and demanding one, which leaves all too little time or energy to indulge in more specialised interests. Nevertheless, he is considered to be a designer of distinction and it is interesting to see him at work at his desk, for, like all craftsmen, he works with natural ease. Let us not be deceived, however, by this apparent ease, for the skill and physical control required to produce beautiful letter-forms time and time again results only from a long and intensive apprenticeship. This inevitably runs into years and however easy it may look to the casual observer it demands a high degree of concentration coupled with strong personal determination.

John Milton Smith, past President of the National Society for Art Education and lay member of the Society of Scribes and Illuminators, has the necessary attributes and expertise. It is quite understandable that this talented but modest artist is looking forward to the time when the demands of an educational role can give way to his ambition to spend more time developing and expanding the range of his calligraphic work.

The Loyal Addresses by John Milton Smith and Thomas W Swindlehurst make an interesting comparison, for although the two styles differ there are similarities and the tutor's influence is apparent. Both pieces of work are designed around a vertical centre line, with the lines of script equally spaced. As this is a well-tried method of presentation the reader might find the following notes helpful.

A useful centring technique

It is sometimes necessary to centre the lines of lettering on a piece of design work such as a scroll or broadside around a vertical axis, and this necessitates the adoption of a simple procedure. I have divided the method which I use into a number of stages and if these are followed you should have no trouble in centring.

I am, of course, assuming that a preliminary design has been prepared, that the size of the lettering has already been determined, and that the vellum or hand-made paper has also been prepared and lined up in readiness for the final writing of it, with a faint centre line drawn vertically in pencil. I often use a thumb-nail or finger-nail instead of a pencil, to produce almost imperceptible grooves. This should be done on a piece of good quality paper cut to the exact size of the final one and lined up in readiness for the lines of script and titles, etc. It should have a margin line near to the left-hand side but there is no need for one on the right.

E John Milton Smith, calligrapher, writing at his desk. His pen is held in a comfortable position and he is obviously relaxed

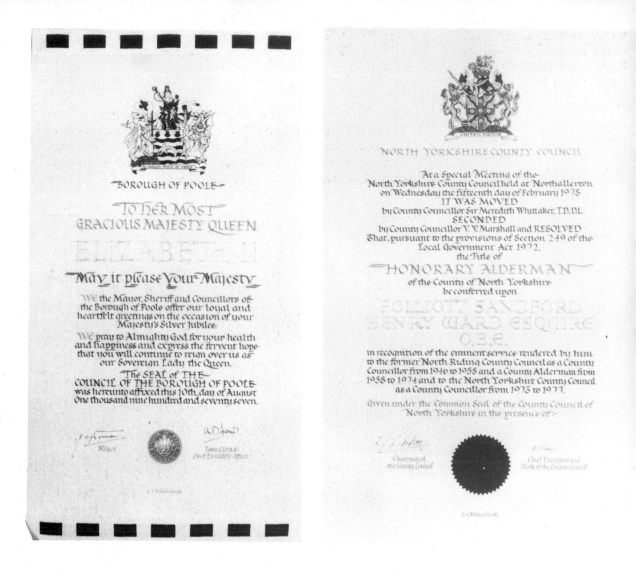

*Loyal Address in black, red, blue
and raised gold on manuscript
vellum 724 mm x 343 mm
(28½ in. x 13½ in.) which was
designed and written by E John
Milton Smith for the Borough of
Poole, Dorset in 1977
Reproduced by gracious permission
of Her Majesty The Queen*

1 Preparing a rough draft

Using appropriate pens (quills or steel nibs) write each title, sub
title and the lines of script from the left-hand margin. This will
give you a good idea of the length of line and an opportunity to
make small adjustments. Number each line of script on the left
of the first letter with a pencil and do the same very lightly on
the final copy.

2 Determining the centre

The lines of script are now cut out as long strips and each one is
folded so that the first letter on the line corresponds with the
last one. Mark the fold with a bold, clear pencil mark.

3 Transferring to the final design

Take strip number 1 (line number 1) and place it underneath
line 1 on the final design with the centre fold on the pencilled

Illuminated address by E John Milton Smith. Reproduced with the permission of the artist

centre line. Mark off with pencil the length of this line. Now do this for line 2 and go on to repeat the operation for every line of lettering.

4 Transcribing

You are now ready to make a start on the final piece of work. Take strip number 1 (line 1) which you have already written in rough and used as a guide to centring, and place it above the guidelines for line 1. Simply write this line, using the rough for reference, and go on to repeat this procedure for the other lines

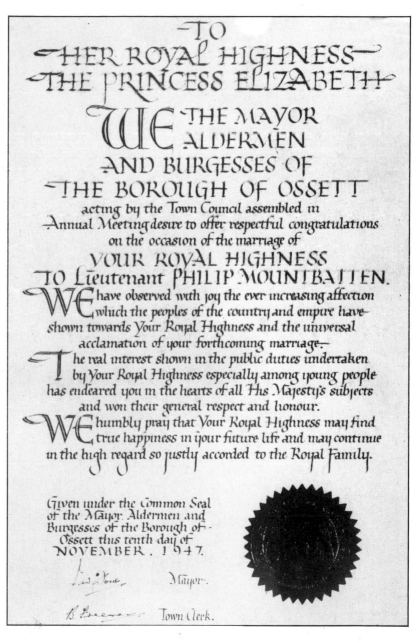

A Loyal Address, executed in gold and colour on calfskin, by the late Thomas W Swindlehurst, on the occasion of the marriage of Her Royal Highness The Princess Elizabeth to His Royal Highness Lieutenant Philip Mountbatten, in 1947. Reproduced by gracious permission of Her Majesty The Queen

95

Loyal Address, in the form of a book-opening, which was presented to Her Majesty Queen Elizabeth II by the Aldermen and Councillors of the County Council of Middlesex, on 31 March 1965. Reproduced by gracious permission of Her Majesty The Queen

Loyal Address, in the form of a page-opening on vellum, bound in blue leather with tooled decoration, presented to Her Majesty The Queen by Berkshire County Council. The artist has used a kind of semi-Gothic or Black Letter for the text, while the illuminated borders are derived from late medieval sources. Reproduced by gracious permission of Her Majesty The Queen

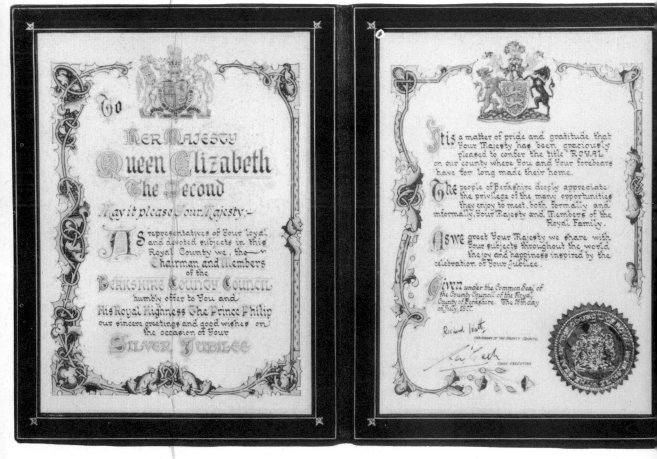

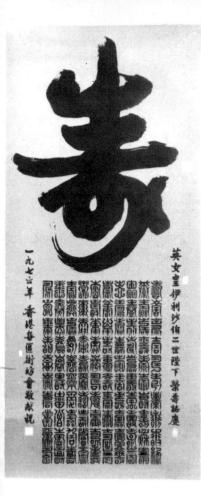

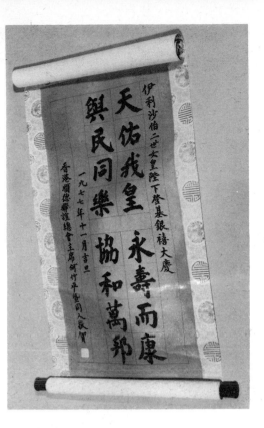

These two Loyal Addresses, in formal Chinese calligraphy, were sent to the Queen on the occasion of her Silver Jubilee, in 1977. They are particularly beautiful examples and show us the vitality of brush-made images. Reproduced by gracious permission of Her Majesty The Queen

of lettering. Because lettering is a human activity, not a perfect, machine-produced phenomenon, you might find that your final draft varies slightly from the rough. Lines of script may be a little longer or shorter, causing you slight visual problems. With a little experience however, you should become adept at squeezing letters together almost imperceptibly so that a long line becomes slightly shorter; or you might need to extend a line which is a little too short, with flourishes or simple, penned designs.

Examples of well-planned and centred pieces of work are to be seen on pages 94 and 95.

Italic handwriting

Many people encounter difficulties in acquiring reasonable writing. The speed of modern living certainly discourages beautiful handwriting, and even I must confess to scribbling rapid notes with a ball-point pen, picking up the phone instead, and even using a typewriter. What is more, my own italic handwriting varies from the basic style I adopted some years ago. It is neat and precise if I take time and care, while being somewhat careless when I dash if off quickly.

What is important is that your writing should be done with care. It should be even and legible in order to be easily read. I don't advocate the adoption of an italic hand myself, for it doesn't suit everyone's tastes or penmanship. Choose a style which is right for you. Those of you who have a desire to pick up a square-ended pen, however, should abide by one or two basic rules:

Hold the pen in a comfortable and natural position

Slope the letters very slightly to the right so that you produce a nice running hand which is quick to write and easy to read

Squeeze the letters a little so that they will lose their roundness

Use diagonal joins

Italic, humanistic cursive, reached a peak in the sixteenth century and came to England from Italy when scholars and scribes came to this country. Queen Elizabeth I learned to write in this style from Roger Ascham.

Practice in italic handwriting
You will require a square-ended pen, which you should hold comfortably in the right hand so that its square end forms, as in formal script, a writing angle of 30° to the horizontal line. The width of the pen will determine the size of the writing. I normally use a William Mitchell nib number 4 for small work, a number 6 and a number 3 for larger writing. Because this style of informal cursive is taller and more angular than formal script I suggest that you base it on these proportions: capital letters ten pen widths; lower-case letters five pen widths — with the

5 pen widths

5 pen widths

Writing line

5 pen widths

ascenders going up to ten pen widths and the descenders going five pen widths below the writing line (see diagram). Your italic handwriting will change in character if you vary these proportions, ie 7 (ascenders), 5 (lower-case) and 7 (descenders) *or* 9 (ascenders), 6 (lower-case) and 9 (descenders).

Ideas
1 I suggest that you copy my example (illustration A), practising both lower-case and capital letters firstly as single letters, then as complete alphabets. Remember, however, to maintain a smooth flowing rhythm.
2 Now go on to write a page of prose — taking a brief passage from a newspaper or novel. Try to maintain a formal italic quality.
3 Re-design the Regent Gallery notice (page 102), this time on a vertical panel 254 mm x 203 mm (10 in. x 8 in.) and in black and red.

Books
I intend only to introduce some examples here but the reader might be interested in referring to a number of books on the subject:
The Story of Handwriting by Alfred Fairbank (Faber and Faber) A useful historical note and reference to what is happening today.
The Art of Written Forms by Donald Anderson (Rinehart and Winston)
Calligraphic Lettering with Wide Pen and Brush by Ralph Douglass (Watson-Guptill) A particularly useful book for the learner since the author deals with the construction of italic letters by means of a series of exercises.
The Young Calligrapher by William Cartner (Kaye and Ward) These should be useful as resources while introducing you to good techniques.

abcdefghij klmnopqrstuvwxyz

Italic script – 20th. century.

ABCDEFGHIJKLMNO
PQRSTUVWXYZ

Thaws are sometimes surprisingly quick, considering the small quantity of rain. Does not the warmth at such times come from below? The cold in still, severe seasons seems to come from above, for the coming over of a cloud in severe nights raises the thermometer abroad at once full ten degrees. The first notices of thaws often seem to appear in vaults, cellars, etc. If a frost happens, even when the ground is considerably dry, as soon as a thaw takes place, the paths and fields are all in a batter. Country people say that the frost draws moisture. But the true philosophy is, that the steam and vapours continually ascending from the earth, are bound in by the frost, and not suffered to escape till released by the thaw. No wonder then that the surface

Meteorological observations from the Diary of Reverend Gilbert White, November 1768

Written in an italic hand by John Blamires

REGENT GALLERY

Invites you to inspect the largest selection of Antique Maps and Prints in the West of England. Our large stock includes material relating to many foreign countries including America, Canada, Africa, Australia, Italy, Switzerland, and Germany, besides maps and views of the British Isles.

Included in our collection are prints of birds, flowers, fishes, caricatures, ships, horses, soldiers, dogs, fruit, crafts and many others. Open Daily (Except Mondays) from 10 a.m. to 5.30 p.m. and you will be most welcome to come and browse through our extensive stock at leisure.

14 REGENT ST. CHELTENHAM

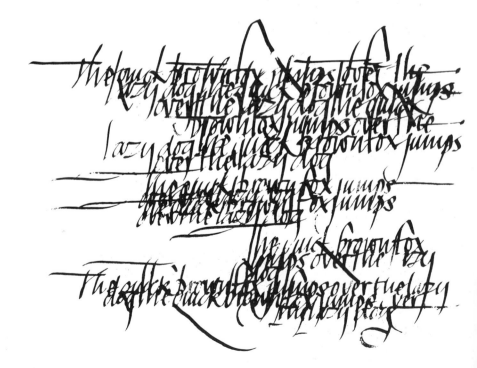

Autographed letter of Henry V giving directions for the defence of the northern borders, and for the safekeeping of prisoners taken at Agincourt in 1415. Reproduced by courtesy of the British Library (Ref: Cotton MS. Vespasian F. iii, f. 8. MSS 100)

To GIORGIO VASARI

Already now my life has run its course,
And, like a fragile boat on a rough sea,
I reach the place which everyone must cross
And give account of life's activity.

Now I know well it was a fantasy
That made me think art could be made into
an idol or a king. Though all men do
this, they do it half-unwillingly.

The loving thoughts, so happy and sovain,
Are finished now. A double death comes near —
The one is sure, the other is a threat.

Painting and sculpture cannot any more
quieten the soul that turns to God again,
to God who, on the cross, for us was set.

Sonnet by Michelangelo

Sonnet by Michelangelo written in a cursive italic hand by the author

The nibs used for Italic writing should have a square edge. It is advisable when practising to use the widest nib in the range. As you gain more skill, and speed becomes more important, reduce the width of nib to medium or fine. If you are left-handed then you require a left-oblique nib.

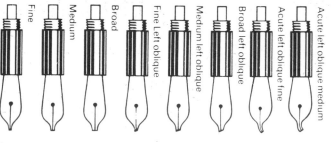

Fine · Medium · Broad · Fine Left oblique · Medium left oblique · Broad left oblique · Acute left oblique fine · Acute left oblique medium

These SPECIAL LETTERING NIBS will also fit your Platignum pen

B2

B3

B4

To replace a new or different nib into the pen, hold the pen firmly by the lower end and take the nib in your other hand flat between finger and thumb, and unscrew. Do not use pliers or force. Simply screw in your new nib unit firmly.

SILVERLINE PEN

This pen has pressmatic filling. Unscrew barrel and squeeze filler bar. Immerse nib in ink and release pressure on filler bar keeping nib immersed for 5 seconds. For maximum fill repeat two or three times. Wipe nib and replace barrel. Wash pen occasionally by repeating filling action with luke warm water. Do not use waterproof inks in a fountain pen.

CARTRIDGE QUICK-CHANGE PEN

This pen is filled with a plastic ink cartridge. It is convenient, quick and clean. All you have to do is to fit a cartridge into barrel. When it runs out simply re-load with another. Refills are available in blue, black, red and green ink.

Specially manufactured fountain pens are used by many calligraphers for doing italic handwriting and this instruction sheet has been prepared by the Platignum Pen Company. Reproduced by courtesy of the Platignum Pen Company

SOME HINTS ON SPACING AND PRESENTATION

Good handwriting not only involves the making of well-shaped letters, but of grouping them together into words, lines and pages. Attention to these details is necessary to make your writing easy to read and pleasing to look at. Keep an eye on the following points.

1. Do not pack your letters close together (a). This can be trying on the eyes. As most letters are joined together with a diagonal stroke let this act as your letter spacer. When practising, imagine a 'U' shape in between letters (b).

2. Allow the space of a letter 'O' in between words.

3. Sufficient space must be allowed in between lines of writing to avoid the overlapping of the ascending and descending strokes (a). A space of two 'O' shapes high, is a useful guide (b).

4. Do not start and finish your lines of writing up to the extreme edges of your paper. It improves the appearance of a page of writing to 'frame' it with a white margin. (See diagrams.)

5. Perhaps the most common purpose for which handwriting is used is personal correspondence. These diagrams suggest some alternative layouts for (a) letterheadings, and (b) envelopes.

1a) *tightly* b) *ample*

2) *word spacing*

3a) *grip* *lash* b) *spray* *bead*

4)

too small too large correct double page

5a)

b)

Spacing and presentation for italic handwriting. Reproduced by courtesy of the Platignum Pen Company

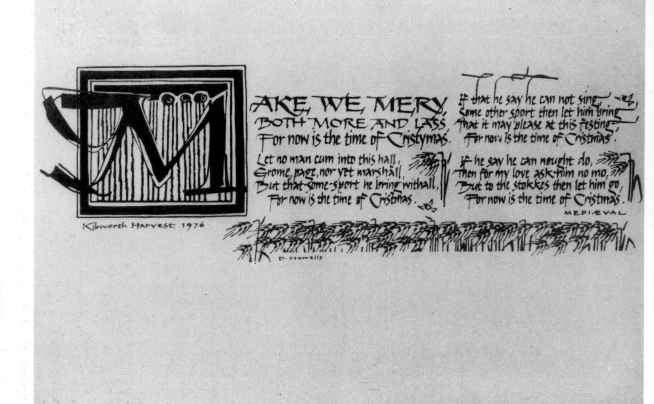

MAKE WE MERY,
BOTH MORE AND LASS,
For now is the time of Cristymas.

Let no man cum into this hall,
Grome, page, nor yet marshall,
But that some sport he bring withall,
For now is the time of Cristmas.

If that he say he can not sing,
Some other sport then let him bring,
That it may please at this festing,
For now is the time of Cristmas.

If he say he can nought do,
Then for my love ask him no mo,
But to the stokkes then let him go,
For now is the time of Cristmas.

MEDIÆVAL

Kibworth Harvest 1976

D. Howells

By David Howells, an example of bold and effective use of italic lettering

Michael Knight Eq
The Hill Residential College,
Pen-y-pound,
ABERGAVENNY · Gwent NP77RP.

San Girolomo, Fiésole. 21·VIII·

Florence - Galleria Uffizi - Botticelli - La nativité de
Venus (detail)
Florence - Uffizi Gallery - Botticelli - The birth of
Venus (Detail)
Florenz - Uffizi Gallerie - Botticelli - Die Geburt von
Venus (Detail)

Our days are spent with Fra
Angelico, Masaccio, Gozzoli,
Botticelli, Leonardo and all the
great host ; our nights in an
old convent-become-hotel on
this enchanted hilltop. It has
its own olives, vines, figs, lemons
& peaches, & we drink its own
good wine. Tomorrow we drive
on to Arezzo, Assisi, Siena &
San Gimiuiano for a week ; then
into Provence (Arles & Avignon)
for our final week. We often speak
of you & wish you cd. be here.
Loving greetings from Heather,
Dietrich & Robin.

Mr. & Mrs. J. Lancaster,
27, Langdale Drive,
Scawthorpe, DONCASTER,
Yorkshire,
INGHILTERRA.

This beautiful italic handwriting is
by Robin Tanner, who is a left-
handed calligrapher

Scripts of the Middle East

The area of the world embraced by what we know as the modern Middle Eastern States, lies strategically between the cultures of the East and West and is where lettering was actually born. Calligraphy is looked upon by its peoples as an art-form, as well as a means of communication, and is closely related to its religious movements. The main three scripts of this area are Cyrillic, Arabic and Hebrew, all three being interrelated, and it appears that Cyrillic actually owes something both to the influence of Greek and earlier Phoenician forms.

As a general rule the traditions of writing developed from Aramaic. A wide qualam, or reed pen, is employed '. . . and the hand is rotated almost 90 degrees left for writing position. . . .' (Donald Anderson in *The Art of Written Forms*, page 297). Arabic calligraphy has a strong and simple graphic beauty that has a compelling fascination for the student, and the words tend to flow together so that a page of writing has visual unity. There are many variations of style but the examples shown here are sufficient to give you a taste of the delights which the scripts of this area offer to us.

This is an example of beautiful, bold penmanship from a Koran. Surah XXVI written on vellum. Arabic manuscript tenth century. Reproduced by permission of the British Library *(Ref: OR 1397 f. 13R BL 308913)*

Hebrew calligraphy developed from Aramaic. Early tenth century. Reproduced by permission of the British Library *(Ref: OR 445 f. 89R BL 780448)*

This old Syriac script has the roundness which results from a round-tipped pen. Vellum manuscript fifth century. Reproduced by permission of the British Library *(Ref: ADD 14451 f. 49V)*

Arabic script on a manuscript written in Egypt in the fourteenth century. Reproduced by permission of the British Library (Ref: OR 1401 f. 468^V)

A page-opening of Arabic script from a thirteenth-century Koran. Reproduced by permission of the British LIbrary (Ref: OR 1009 f. 115^V-116^R)

Arabic script on a cheap leather cigarette case

Islamic script which when translated, reads: 'Fight those who believe not in God nor the last day'

قَاتِلُوا الَّذِينَ لَا يُؤْمِنُونَ بِاللَّهِ وَلَا بِالْيَوْمِ الْآخِرِ

Islamic writing characterized by its sweeping calligraphic strokes. It reads: 'Seek knowledge, even in China'

اُطْلُبِ الْعِلْمَ وَلَوْ فِي الصِّينِ

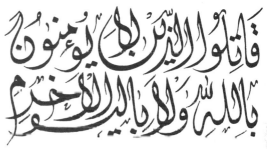

بنك الإتحاد العربي

Allied Arab Bank Ltd

Arabic lettering from a British newspaper

Incised lettering

Lettering has been incised into all manner of suitable materials — including stone (marble, slate, sandstone, granite, etc) bone, wood, wax and even clay — since Palaeolithic times. Indeed the wedge-shaped forms of cuneiform letters were especially suited to interpretation in soft clay and stone, while the monumental hieroglyphics used by the Egyptians to adorn their temple walls could be claimed to be the first inscriptions of architectural merit. However it was the letter-cutters associated with Ancient Rome who raised incised inscriptional forms to their highest and most significant level, and it has already been noted in the historical section that these achieved a standard of technical and aesthetic perfection that has never been surpassed.

I intend to make only a brief reference to the carving of lettering, and shall concentrate upon the work of Bryant Fedden, a craftsman who works in stone and glass. He, like all letter-cutters in stone, uses chisels, hammers and mallets in his work, holding his hammer-headed chisel comfortably in his left hand and striking it with firm, tapping strokes with a mell (a mallet) held in his right hand. As a student I was taught to forge my own chisels and to employ a two-pound hammer, instead of a mallet, although individuals must make their own choice of implements.

It is vital to keep the chisel correctly tempered and with its cutting edge keenly sharpened. This will ensure that the letters are cut crisply while giving the most pronounced light and shadow effect.

An incised V-section

Carving incised V-section letters

1 The stone surface to be carved must be even and smooth and this can be effected by rubbing it with a piece of sandstone and water. Alternatively, a local stonemason will supply stone prepared to your requirements.

2 You will need to draw guidelines for your lettering on the prepared surface with a ruler and pencil or chalk (these could be lightly scratched into the surface of the stone) — including vertical centre and marginal lines.

3 Draw the intended lettering on to the stone with either pencil or chalk. (I shall assume that this will be of a classical Roman style).

4 In carving this lettering the object is to produce a clean V-section (see illustrations) with the lowest part of the incised cut in the very centre of each stroke. Eric Gill gives us simple but clear guidance, saying: '. . . it is best to hold the chisel at an angle of 45° with the surface of the stone in cutting both straight stems and curves. The chisel is held firmly (usually in the left hand, with the little finger about an inch from the cutting end of the chisel), tapped rather than banged, and lightly rather than heavily.

 The best way to cut an ordinary letter is to start at the left-hand side at the bottom, and, working upwards, to cut the left side of the stem first. Similarly cut the right side of the stem, and then cut the serifs. When cutting a curve, cut the inside first, and start as near the narrowest part of the letter as possible.' (Note 7)

5 Sometimes it is necessary to paint or gild the incised surfaces of such carved letters, using a lacquer or gold leaf, so that they are legible in the dark interior of a building. Out-of-doors, of course, the changing effects of sunlight give an additional interest.

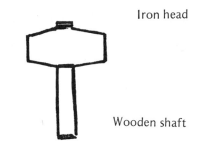

Iron head

Wooden shaft

A two-pound hammer

A wooden mallet

Carving letters in relief (raised sections)
The use of lettercarving tools and methods are the same for carving both incised and relief letters. However, having carved the letters in relief it is necessary to cut away the surface of the stone around them. (See the two examples A and B.)

A The usual raised section

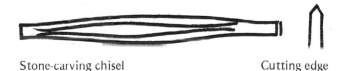

Stone-carving chisel

Cutting edge

B Raised section used for large letters

Wood-carving chisel with a wooden handle

A Gloucestershire craftsman

Bryant Fedden, letter-cutter and glass-engraver, lives and works in Winchcombe, in Gloucestershire. What I find absolutely fascinating about this gifted craftsman is that he is self-taught. The restrictions of a formal art and design education were not suitable for him. Rather, he has developed, through personal experience and trial and error an individual approach to this important aspect of the visual arts that exudes a deeply felt sensitivity to pattern and form and a seemingly natural ability

113

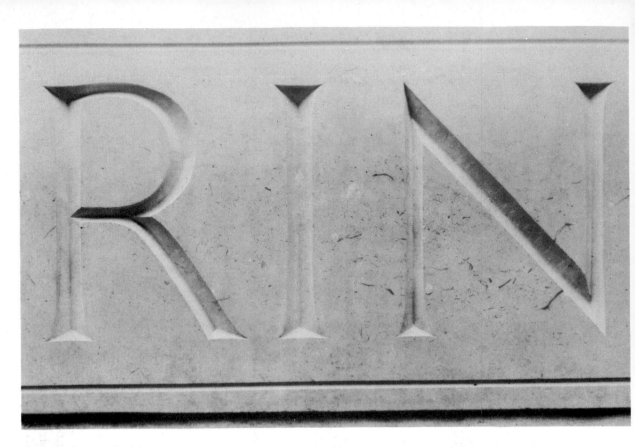

I based these incised letters on classical Roman forms. They are 305 mm (12 in.) in height and approximately 20 mm (¾ in.) in depth

Horizontal V-section

This illustration shows a horizontal V-section through an incised letter which was carved in stone — produced by the action of the hammer and chisel

to combine these as a total visual experience with his selected materials.

He is a modest craftsman who readily admits to having been influenced by a small number of eminent designers, although his initial education (he read English and History at Cambridge) was quite different to that undertaken by the more orthodox art student or trainee-apprentice.

The Bryant Fedden Workshop was established in 1967 and specialises in the production of sculpture, letter-cutting, and glass-engraving. Commissioned work has included kinetic sculptures for Newton Abbot racecourse, sculptures in stone and wood, fountains in stone, engraved glass windows, notably the three 4.5 m (15 ft) windows in the Chapter House of Bristol Cathedral, and engraved table-glass such as a large goblet now in the Victoria and Albert Museum in London. Foundation stones, tablets, Stations of the Cross and memorials have been made for such places as Bristol, Gloucester and Manchester Cathedrals, for firms and churches throughout the country as well as for the Library of the University of California in Los Angeles, for Wellington School and for the Library of Chelsea Royal

Bryant Fedden, the letter-cutter, putting finishing touches to one of the letters on a slate panel

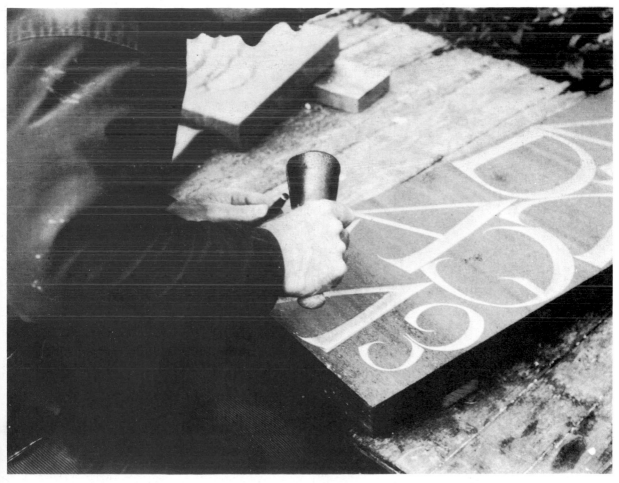

Hospital. Font tops, fountains, topographs and abstract sculptures as well as simple incised signs and gravestones are typical products of the workshop.

In dealing with incised lettering I have concentrated simply on the work of one designer. However, the reader will find the following names of interest — Evetts, Gill, Kindersley, Ledward, Mansell, Parr, Percy Smith, and Wrigley, to mention a few established artists — and might like to note that the Guild of Memorial Craftsmen, of which I was a member for some years, is concerned with promoting high levels of design.

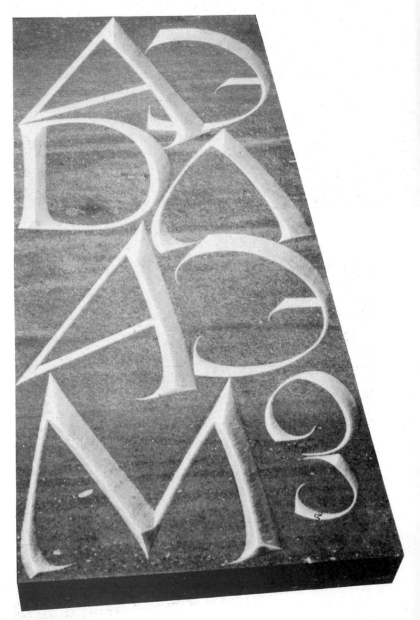

A very interesting example of freely cut lettering by Bryant Fedden. Note the deeply incised V-section which gives a distinctive character to the lettering

116

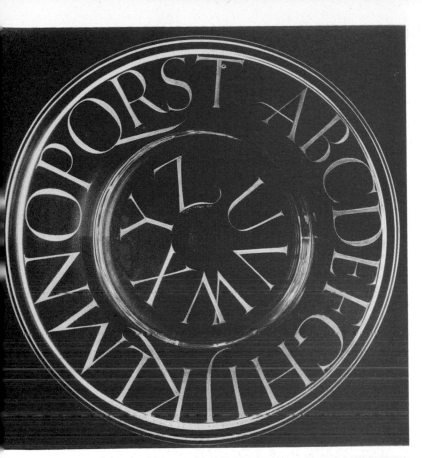

An alphabet engraved on a glass plate by Bryant Fedden in 1971

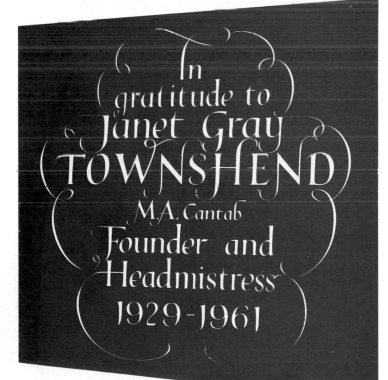

In
gratitude to
Janet Gray
TOWNSHEND
M.A. Cantab
Founder and
Headmistress
1929-1961

Bryant Fedden engraved this window and a strong affinity is discernible, in his use of letter-shapes and flourishes, between this and his work in stone

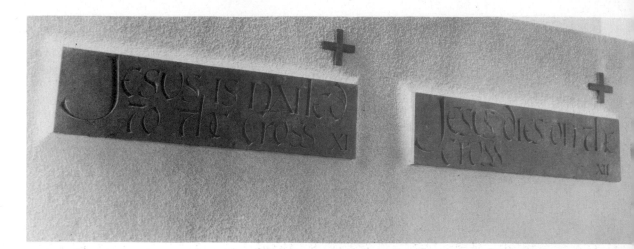

Two of the Stations of the Cross designed by Bryant Fedden for a Roman Catholic church in Stonehouse, Gloucestershire. The random lettering is bold, legible and decorative, and is set off by the simple surface of the wall on which these Horton stone tablets are mounted

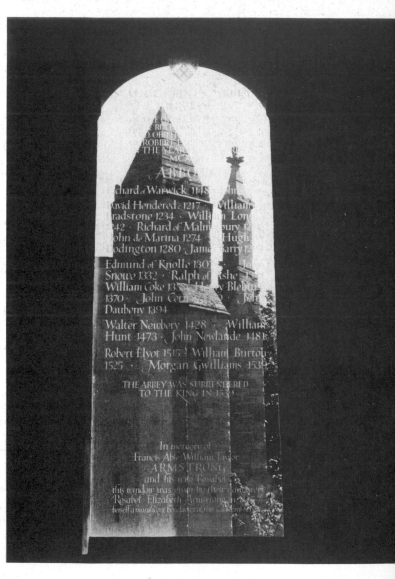

This is one of three engraved glass windows in the Chapter House of Bristol Cathedral, designed and executed by Bryant Fedden. The lettering can be seen against a background of medieval masonry and an ever-changing sky, relating well to these and adding a delicate textural effect. At night, when the interior lights of the cathedral illuminate the windows from within, a subtle change occurs and the visual effect is altered

118

This photograph shows Bryant
Fedden working on one of the
panels of glass for Bristol Cathedral
using a dentist's drill to engrave
the letters

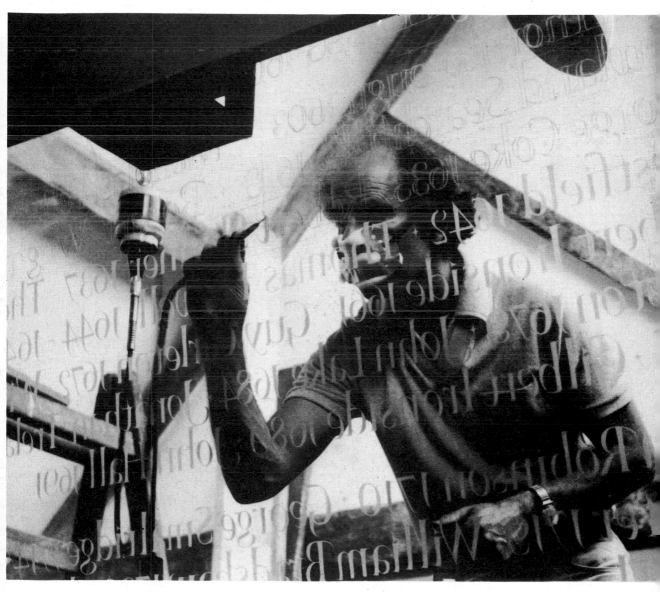

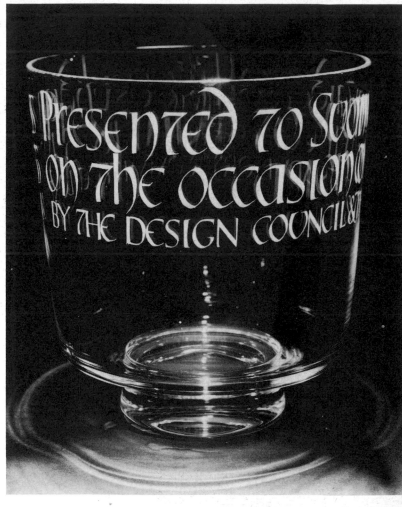

Further examples of flexible-drive engraving by Bryant Fedden on glasses, goblets and bottles

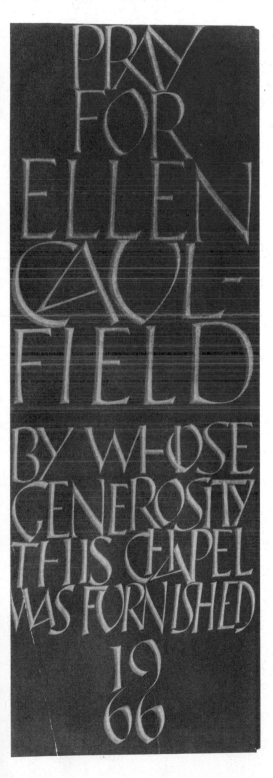

A memorial, in slate, to Walter and Elizabeth Williams Field which relies for its effect upon a simple design and clear-cut letters. Designer: Bryant Fedden, 1961

PRAY
FOR
ELLEN
CAUL-
FIELD

BY WHOSE
GENEROSITY
THIS CHAPEL
WAS FURNISHED
19
66

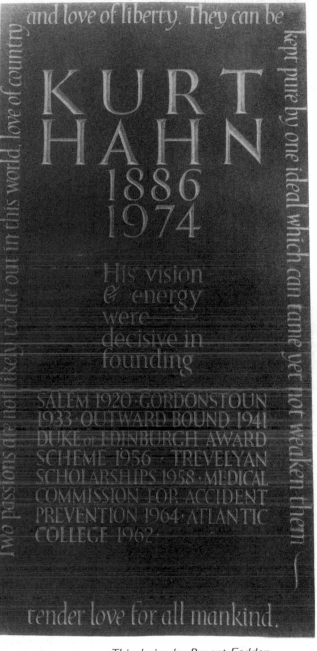

and love of liberty. They can be kept pure by one ideal which can tame yet not weaken them

KURT
HAHN
1886
1974

His vision
& energy
were
decisive in
founding

SALEM 1920·GORDONSTOUN
1933·OUTWARD BOUND 1941
DUKE of EDINBURGH AWARD
SCHEME 1956 · TREVELYAN
SCHOLARSHIPS 1958·MEDICAL
COMMISSION FOR ACCIDENT
PREVENTION 1964·ATLANTIC
COLLEGE 1962·

Two passions are not likely to die out in this world. love of country

tender love for all mankind.

This design by Bryant Fedden incorporates capital and lower-case letters that have a strong and majestic feel, while the band of lettering running around the edge of the tablet adds an interesting patterned effect

121

The lettering on this memorial tablet to William Whitehead Hicks Beach, MP, is more freely conceived. It relates well with the spirit of the memorial, however, and fits nicely into the overall shape. Designer: Bryant Fedden, 1975

I am particularly drawn to Fedden's use of freely carved lettering. Those in this example are obviously based on versal letter forms, which lend themselves well to such an approach and they seem to exude a feeling of spontaneous excitement that makes the tablet a visual delight

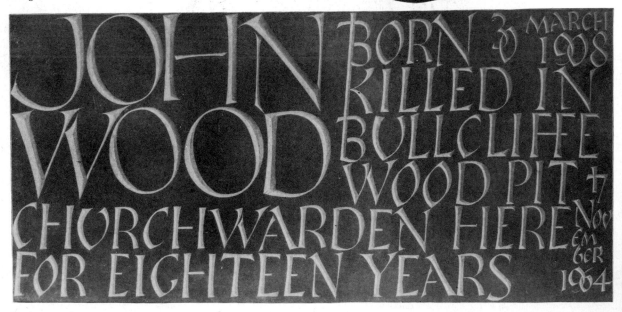

In loving memory of
WILLIAM
WHITEHEAD
HICKS BEACH
of Witcombe Park
Eldest son of Ellis Hicks Beach
BORN 23rd MARCH 1907
DIED 1st JANUARY 1975
He was a soldier lawyer sportsman
and Member of Parliament for
Cheltenham for 14 years
and his life was spent in
service to his country
and fellow men.

JOHN WOOD BORN 3rd MARCH 1908 KILLED IN BULLCLIFFE WOOD PIT 17 NOVEMBER 1964 CHURCHWARDEN HERE FOR EIGHTEEN YEARS

Chinese and Japanese lettering

"the aesthetic of Chinese calligraphy is simply this" : that a beautiful form should be beautifully executed"

But this is a universal principle of all art and it implies, not merely that the work of art should be formally perfect; but that it should also be

ORGANICALLY VITAL.

Herbert Read - "Chinese Calligraphy" by Chiang Yee Lancaster scripsit·

Ancient Chinese writing appears to have been invented somewhere near the time when the earliest classical forms were coming into being in the lands around the Mediterranean. This was in the Shang dynasty, between 1765 and 1123 BC, when images where incised on animal bones and from which the basic characteristics of Chinese were evolved. Later, in the Chou dynasty, up to 256 BC, inscriptions appeared on a variety of bronze utensils and these demonstrated the geometric nature of the imagery used. The artists of that time also carved similar forms in stone and many of these have been preserved for us.

In the Ch'in dynasty which followed, in 221 BC, a reform of written lettering took place and a basic set of signs was created. This was really an attempt to give a formal structure and unity to a language which was comprised of a staggering total of 9000 characters, clearly an enormous but essential task, and the new writing style which was created was known as *hsiao chuan*, or 'lesser seal style', in contrast to the older style of *ta chuan*.

The individual characters of Chinese lettering which subsequently evolved are symmetrical in nature and are based on an imaginary square sub-divided as in the illustrations. What I did was to get a Chinese student of mine to write the word *yeow* (meaning friend) within such a square, and in the illustrations you will see that he did this in a semi-formal calligraphic script (*shu fa*).

Each character in the Chinese language is, as Ch'en Chih-Mai says, 'an artistic unit', and the calligrapher struggles to create an artistic composition in putting the units together. Ch'en Chih-Mai's book, *Chinese Calligraphers and Their Art* (Melbourne University Press), is a veritable source of information for those who wish to study Chinese lettering more thoroughly than this brief section will permit, for he goes into the subject deeply. *Chinese Calligraphy*, by Yee, (Methuen) is another excellent text which is amply illustrated.

What is remarkable about the Chinese language is that its development has had a strong continuity. The use of the pointed brush has given its characters their individual beauty of

form, in contrast to most of the lettering of the West which has resulted from quills and reed pens. If you wish to have details of brushes, pigments, papers and the actual formation of Chinese characters, then I suggest you read Chapter 16 in *The Art of Written Forms* by Donald Anderson, (Rinehart and Winston). The section which John Biggs devotes to Chinese and Japanese lettering in his book *Letter-Forms and Lettering* (Blandford Press) is also a very good one for the intending student. However, I feel it is enough simply to enjoy the visual delights offered to us by these oriental scripts, and shall let you enjoy the illustrations.

I was fortunate in obtaining a number of excellent examples of lettering in the environs of Hong Kong which were photographed by Catherine Redding an ex-student of mine, and as you can see these pulsate with an everyday pragmatism which in no way detracts from their beauty. Sadly, however, I am informed that many Chinese people no longer learn how to do calligraphy with a brush for — as in our own culture — the ballpoint pen and typewriter have tended to degrade beautiful script forms.

Japanese lettering
Japanese lettering developed from Chinese and the similarities are apparent, although scholars would appreciate the vast differences or nuances which are too subtle for the untrained eye. Again, the individual characters result from the pointed brush and have a beautifully simple and abstract quality. I have few examples, but you will find Yujiro Nakata's book *The Art of Japanese Calligraphy* (Heibonsha Survey/Wetherhill) a veritable mine of information and a splendid compendium of styles and traditions. It is superbly illustrated and should encourage a deeper interest in a fascinating aspect of visual communication.

Practical ideas
If you are keen to attempt some Chinese lettering, and I certainly agree that it would be interesting to experiment, you will need to prepare well for it. You will require some black, Chinese non-waterproof ink (Chinese stick ink), although a good quality fountain pen ink would serve you well; a Chinese calligrapher's brush or one or two good watercolour brushes (numbers 4, 6, 8 and 10 according to the size of image to be produced).

What you must remember is that it takes the expert Chinese calligrapher many years to master the use of the brush and that his period of training is an intensive one. Your attempts, then, are hardly likely to match his but will intensify your appreciation of this beautiful art-form which is written from the right to the left-hand side of the page not from left to right as in the Western world, in vertical columns.

A semi-formal style of Chinese calligraphy, meaning 'sharing each other's friendship'

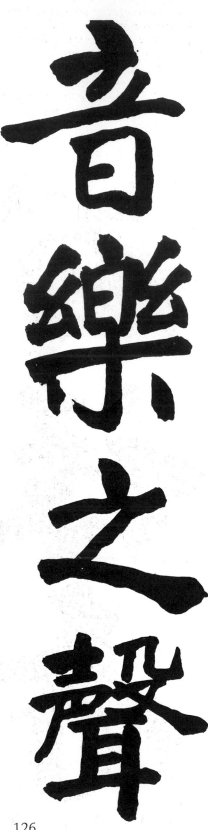

This is a rather more formal style whose brush strokes are ragged at the edges. When translated it reads: 'very happy sound and song'

This quite beautiful script is of a more sharply angular type, with the vertical lines slightly emphasised. When translated it reads: 'bon voyage' and is meant for those going overseas.
Reading from the top the characters are:

Yat	— one
Fun	— junk (boat)
Foong	— wind
Sen	— smooth

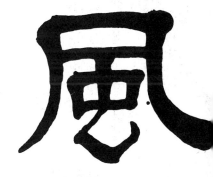

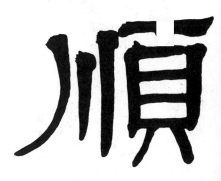

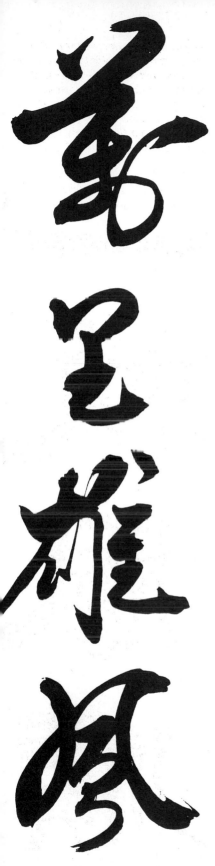

Another example of a very lovely cursive form in a personal rather than a formal style. In translation we have: 'easy and safe journey' or 'bon voyage'

This is a lovely cursive script whose brush strokes are fluid and continuous. Reading from top to bottom:

Fook — prosperity
Loke — wealthy
San — long life

So the meaning should be clear as it conveys birthday greetings and well-wishes

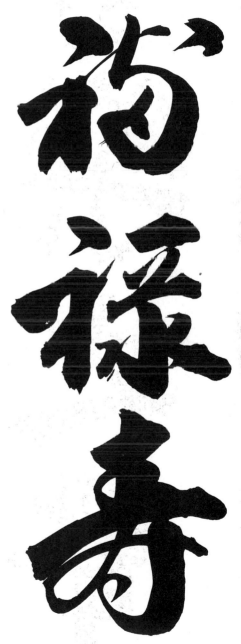

127

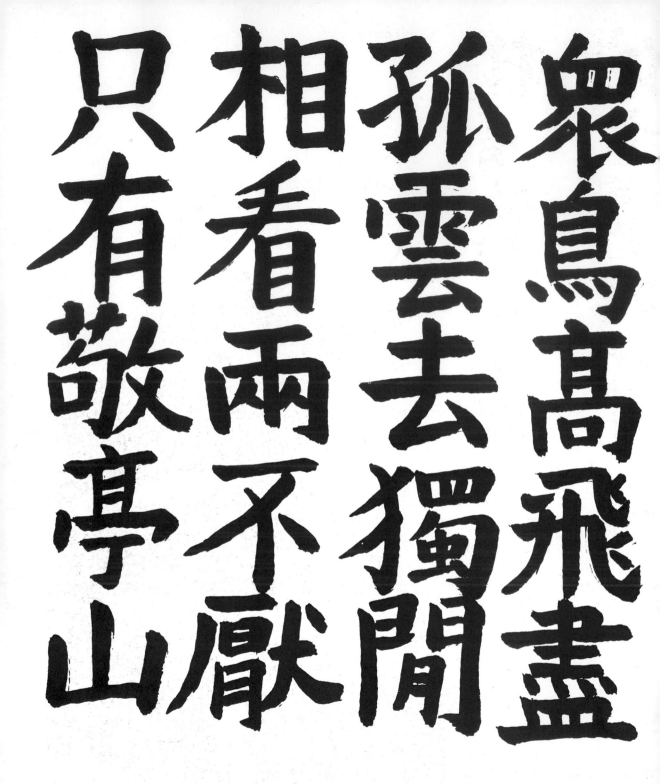

衆鳥高飛盡
孤雲去獨閒
相看兩不厭
只有敬亭山

An example of Chinese lettering by
a student at the University of
Bristol

128

横眉冷对千夫指

俯首甘为孺子牛

The two examples at the top of this picture are old Chinese signs for wholesale medicine and an import and export merchant

129

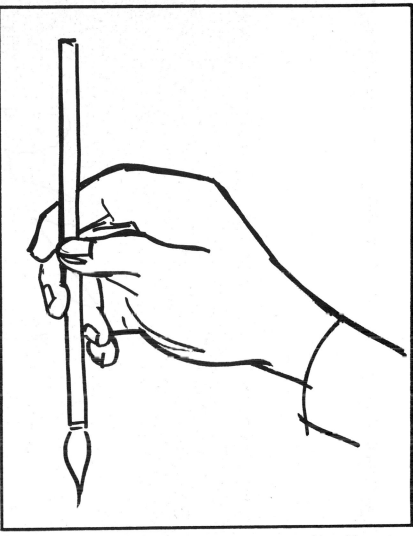

1 Holding the brush — the basic shuang mou or P'ing-Wan grip
Take the brush in the right hand (not in the left) and hold it in
a vertical position (see illustration). The writing is done on a flat
horizontal surface on a coarsely woven porous paper and with
the hairs straight. Your wrist must be parallel to the flat
writing surface, with the fingers and palm hollow and the brush
in a line with your nose. When you do small calligraphy you
may rest your wrist on your left hand with the Chen-Wan grip.

2 The basic strokes
In Chinese calligraphy there are eight basic strokes and the
illustration shows that they are all constituents of the *Ung*
character. Practise these — as single strokes — and then combine
them, as in the *Yung* character, using a square as a basic frame-
work to help you. These strokes result from a delicate handling
of the three main brush movements — *Tun* (to crouch), *T'i* (to
raise) and *Na* (to press down firmly).

*Handwritten notices in a side-street
in Hong Kong. They refer to a
letter-writer, an estate agent, an
employment agency and a poster-
writer.* This and other photographs
taken in Hong Kong are by
Catherine Redding

131

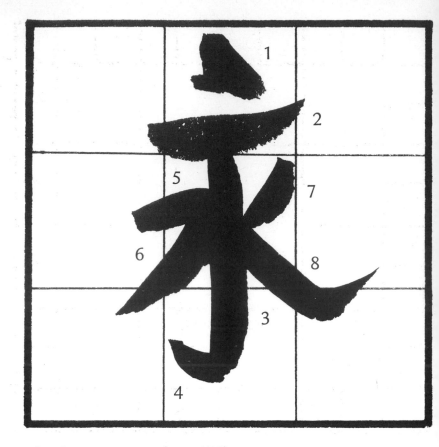

3 Practice squares (page 134)

You will find it helpful to prepare a number of squared practice sheets like the one shown in the example. I photocopied my master copy and had ample opportunities to practise single Chinese characters repeatedly. Try this method.

4 A page of Chinese calligraphic characters (page 135)

For this illustration I used a practice sheet on which to render my own freely interpreted versions of 15 calligraphic characters. Just copy it.

5 Large images

Draw a series of 203 mm (8 in.) squares — or bigger if you prefer — and render your own versions of some Chinese script with a large brush. Do these freely and boldly, and don't worry if you images are not perfect copies.

6 A decorative panel — 254 mm x 254 mm (10 in. x 10 in.)

Plan a basic framework, as shown on page 133, with a felt-tipped pen. It is based on a series of squares in which the large centre square is 102 mm x 102 mm (4 in. x 4 in.) in size, the medium-sized squares around it are 51 mm x 51 mm (2 in. x 2 in.) and the small ones enclosing these are 25 mm x 25 mm

(1 in. x 1 in.). You will obviously use brushes which vary in size according to the size of square, and I suggest that you choose black, red and either green or blue ink in following these instructions:

Select three Chinese letters — characters no. 1, 2 and 3.
Write character no. 1 in red, with your largest brush in the central square.
With the medium-sized brush and black ink produce character no. 2 in each of the 51 mm (2 in.) squares.
Repeat character no. 3, with your smallest brush and either blue or green ink, in each of the surrounding 25 mm (1 in.) squares.

You could develop further ideas as a variation of this one, changing your calligraphic characters, colours, image sizes and even using diamond shapes or rectangles instead of squares. Just be inventive and surprise yourself, but remember at all times that when doing Chinese calligraphy you must concentrate deeply, have the brush in a vertical position and make positive, exactly positioned brush marks.

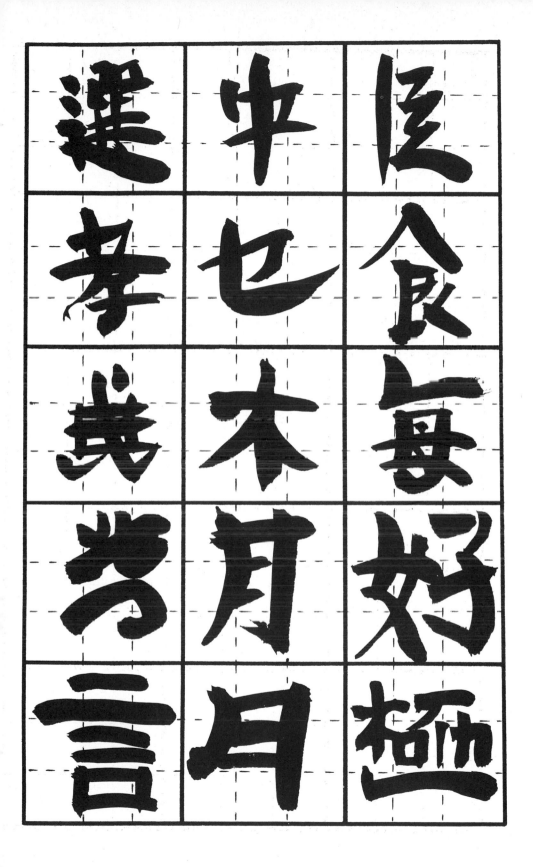

臣	中	準
食	七	孝
每	本	羕
好	月	芳
極	冄	言

Street sign in Hong Kong

An interesting collection of environmental lettering in Hong Kong

Signs for a tailor, and a department store selling watches

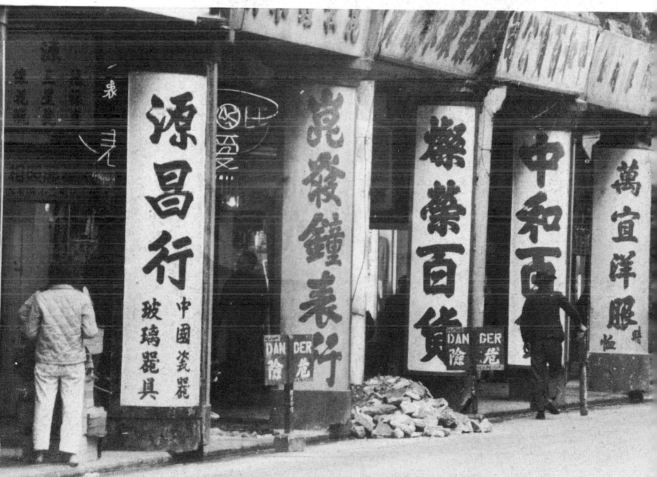

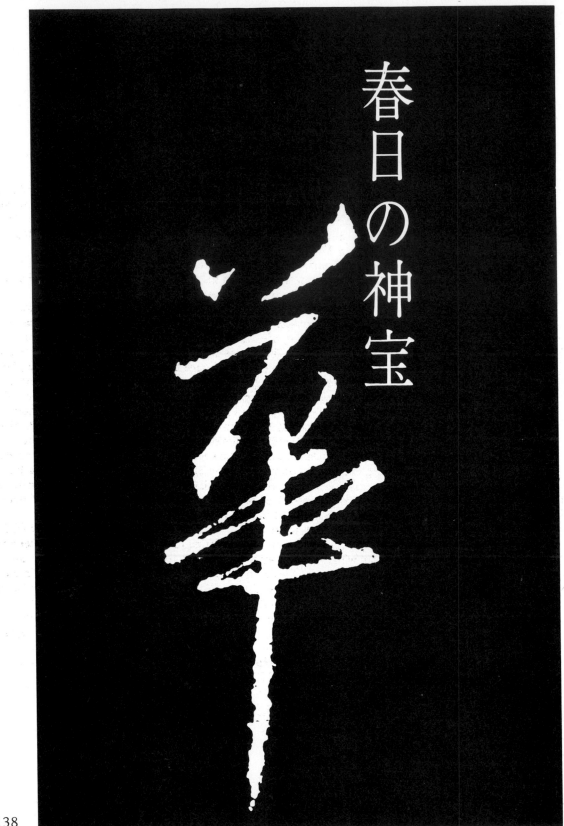

春日の神宝

Notes

1 Martin Buber, *Between Man and Man* (translated by Professor Ronald Gregor Smith) Glasgow, The Fontana Library, 1961, Chapter 3, Education

2 Alfred Fairbank in *Lettering of Today*, edited by C G Holme, New York : Studio Publications Inc., London : The Studio Limited, 1949, pages 13-17

3 This course led to the award of the N.D.D. (National Diploma in Design) which was replaced in the 1960s by the Dip. A.D. (Diploma in Art and Design) and later by the B.A.

4 It is interesting to consider here that not all the scriptoria in the abbeys and monasteries were purpose-built. The cloisters at Gloucester Cathedral, for instance, have one section consisting of a row of small recesses and, according to the diocesan architect who has taken groups of my students on guided tours through this marvellous medieval complex, these were used by the medieval monks for private reading and writing purposes. Rushes would probably cover the stone floor, candles or rush lights provided illumination in the evenings or early mornings, braziers gave off heat, and animal skins or blankets were draped at the ends of the passages in an attempt to eliminate as many draughts as possible. It demands little imagination, however, to hear the coughs, sneezes, scratching of the quills on vellum, the crackle of the burning braziers and the occasional chiming of bells associated with the religious routine. Also, one could envisage the inevitably smoky and draughty atmosphere in which, nevertheless, beautiful works of art were produced

5 The reader might find it useful to consult some books on printmaking if he wishes to pursue monoprinting further, and I would recommend the following: *Approaches to Printing*, my own book published by Evans; *Monoprints for the Artist* by Roger Marsh, a Scopas Handbook; *Creative Print Making* by Peter Green, a Batsford publication and *Printmaking* by Harvey Daniels, published by Hamlyn

6 Donald Anderson, *The Art of Written Forms: The Theory and Practice of Calligraphy*, New York, Rinehart and Winston, 1969, pages 81-82

7 Eric Gill in *Writing and Illuminating and Lettering* by Edward Johnston, Pitman, 1977, pages 353-370

Printed Japanese script

Bibliography

Anderson, Donald M, *The Art of Written Forms: The Theory and Practice of Calligraphy*, New York : Rinehart & Winston, 1969

Biggs, John R, *Letter-Forms and Lettering*, Poole : Blandford Press, 1977

Blunt, Wilfred, *Sweet Roman Hand*, Barrie and Jenkins, 1952

Burgoyne, P H, *Cursive Handwriting*, Leicester : Dryad Press, 1955

Camp, Ann, *Pen Lettering*, Leicester : Dryad Press, 1964

Cartner, William C, *The Young Calligrapher*, Kaye & Ward, 1969

Ch'en Chia-Mai, *Chinese Calligraphers and their Art*, London and New York : Melbourne University Press, 1966

Child, Heather, *Calligraphy Today*, Studio Vista, 1976

Daniels, Harvey, *Printmaking*, Hamlyn, 1972

Day, Lewis F, *Penmanship of the XVI, XVII and XVIII Centuries*, B T Batsford, 1978

Douglass, Ralph, *Calligraphic Lettering with Wide Pen and Brush*, New York : Watson Guptill, London : Pitman, 1975

Evetts, L C, *Roman Lettering*, Pitman, 1948

Fairbank, Alfred, *A Book of Scripts*, Penguin, 1949

Fairbank, Alfred, *A Handwriting Manual*, Faber & Faber, 1975

Fairbank, Alfred, *The Story of Handwriting: Origins and Development*, Faber & Faber, 1970

Gilissen, L, *Prolégomènes à la Codicologie, (Recherches sur la construction des cahiers et la mise en page des manuscrits medievaux)*, Editions Scientifiques Story-Scientia, Gaud, France, 1977

Gourdie, Tom, *A Guide to Better Handwriting*, Studio Vista, 1967

Gourdie, Tom, *Italic Handwriting*, Studio Vista, 1963

Gourdie, Tom, *Improve your Handwriting*, Pitman, 1978

Groudie, Tom, *Calligraphic Styles*, Studio Vista, 1979

Groudie, Tom, *Handwriting for Today*, Pitman, 1971

Gourdie, Tom, *The Puffin Book of Lettering*, Penguin, 1970

Gourdie, Tom, *The Simple Modern Hand*, Collins, 1975

Green, Peter, *Creative Print Making*, B T Batsford, 1964

Lettering Design, Harvey, Michael (ed) Bodley Head, 1975

Lettering of Today, Holme, C G (ed) New York : Studio Publications Inc, London : The Studio Ltd., 1949

Johnston, Edward, *Writing and Illuminating and Lettering*, Pitman, 1977

Ker, N R, *English Manuscripts in the Century After the Norman Conquest*, (The Lyell Lectures 1952-3) Oxford : Clarendon Press, 1960

The Calligrapher's Handbook, Lamb, C M, (ed) Faber & Faber, 1956

Lancaster, John, *Introducing Op Art*, B T Batsford, 1973

Lancaster, John, *Approaches to Printing*, Evans, 1974

Lowe, E A, *C.L.A. Material* (Collection of 2509 prints, arranged in 23 albums) Oxford, Bodleian Library

Marsh, Roger, *Monoprints for the Artist*, Scopas Handbook, 1973

Nakata, Yujiro, *The Art of Japanese Calligraphy* (translated by Alan Woodhull in collaboration with Armins Nikovskis) Tokyo : Heibonsha Survey/London, Wetherhill 1973

Pacht, O and Alexander, J J G, *Illuminated Manuscripts in the Bodleian Library*, Oxford

Vol 1 German, Flemish, Dutch, French and Spanish Schools (1966)

Vol 2 Italian School (1970)

Vol 3 British, Irish and Icelandic Schools (1973)

(R72d R617), Oxford : Clarendon Press

Typewriter Art, Riddell, Alan (ed) London Magazine Editions, 1975

Shahn, Ben, *Love and Joy about Letters*, Cory, Adams and Mackay, 1963

Spencer, Herbert and Spencer, Mafalda, *The Book of Numbers*, Latimer, 1977

Switkin, Abraham, *Hand Lettering Today*, New York : Harper Row, 1976

Thomson George, L, *New Better Handwriting*, Edinburgh, Canongate, 1977

Wellington, Irene, *The Irene Wellington Copy Book* (in four parts) Pitman, 1979

Yee, Chiang, *Chinese Calligraphy*, Methuen, 1954

Zapf, Hermann, *Typographic Variations*, New York : Museum Books, 1964

Materials and suppliers

1 Makes and trade names of instant lettering

Blick Dry Print (Licensed under Letraset)
Fascal Permanents
Instant Lettering (Letraset International Ltd
Letraset (Letraset International Ltd)
Magic Letters
New Presletta
Primark Adhesive Letters
Spacematic (Letraset International Ltd)

Obtainable from local artist's stockists, newsagents or office-supply companies.
Letraset UK Ltd is at 195 Waterloo Road, London SE1 8XJ should you wish to contact them direct.

2 Vellum

A variety of manuscript vellums and parchments for use in writing and illuminating include calfskin, sheepskin and goatskin. (These are supplied by H Band and Co Ltd, Brent Way, High Street, Brentford, Middlesex, who will send a catalogue on request).

3 Pens

It is becoming increasingly difficult to get hold of quills because table poultry is now processed by machines in large factories. You could get to know a local farmer or poultry dealer, however, and ask him for turkey or goose feathers — particularly flight feathers from the wings. A sharp knife (a scalpel is the best) will then be required so that you can cut your own pens (see Edward Johnston's book *Writing and Illuminating and Lettering* or *The Young Calligrapher* by William Cartner, for instructions). Try cutting ordinary garden-canes so that you can write some larger letters.

Square-ended steel nibs, manufactured by William Mitchell, can be purchased locally or from one of the large manufacturers. You will also require three or four pen-holders and some small brass reservoirs. As an alternative you could acquire a fountain pen with special square-ended nibs. (Suppliers include The Platignum Pen Company, Mentmore Manufacturing, Platignum House, Six Hills Way, Stevenage, Herts., Winsor and Newton Limited, 51 Rathbone Place, London W1, Margros and Philip Poole, collector of steel pens, 182 Drury Lane, London WC2).

4 Writing inks

I suggest you try out ordinary fountain-pen inks and water colours — *definitely not* waterproof inks — but for formal calligraphy you will really require a Chinese stick ink and artist's water colours (usually made slightly opaque with the addition of a little white, except for orange vermilion which must be of a pure consistency so that it is bright and rich in colour). (See your local artist's stockist).
Practically any form of colouring medium is suitable for experimental work.

5 Paper

White cartridge paper is good for ordinary work and a hot-pressed, hand-made paper for more formal occasions. I also use coloured card, typing paper and a variety of Japanese hand-made papers. (Obtainable from local stockists.)

Index